APR 1 9 1999

CREATING CURRICULUM IN ART

Phillip C. Dunn
Associate Professor of Art
University of South Carolina
Columbia, South Carolina

1995

The National Art Education Association

About NAEA...

Founded in 1947, the National Art Education Association is the largest professional art education association in the world. Membership includes elementary and secondary teachers, art administrators, museum educators, arts council staff, and university professors from throughout the United States and 66 foreign countries. NAEA's mission is to advance art education through professional development, service, advancement of knowledge and leadership.

About the *Point of View* Series...

The purpose of the Point of View Series is to focus attention on and promote art programs that include a comprehensive approach to art learning, including the interpretation of and viewpoints on the components of the NAEA Goals for quality art education.

The authors were selected because of their knowledge of the topic. While their points of view may differ from others in the field, it is NAEA's mission to advance discussion, examination, and reflection on the content of art education.

About the Cover...

Jacob Lawrence, 1978. *The Library*, screenprint, 10-1/4" x 15-1/8". Permission is granted by courtesy of the artist and Francine Seders Gallery, Seattle, WA.

ISBN 0-937652-88-1

For Drew and Shawn, who tried hard to understand why I had to close the doors to my study so often during the past year; and for my students—past, present, and future. You always end up giving me many more "delicious ideas" to ponder than I can ever hope to give back.

CONTENTS

"Some people see the world as it is and ask, 'Why?' My brother saw the world as it could be and asked, 'Why not?'"

- Senator Edward Kennedy
Eulogy for Robert F. Kennedy

SECTION ONE

SETTING THE STAGE: EXPLORING THE ISSUES

The first three chapters in this book provide background for teachers interested in how the field of art education got to where it is today and in the role curriculum has played in its development. Chapter 1 makes the case for having a written, sequential, cumulative, and well articulated curriculum in art. In addition, this chapter provides a context from which to view art education's position within the educational structure. Chapter 2 lays out the basic elements or components of a curriculum in art, and Chapter 3 provides a selected look at the theories that contributed most heavily to art's curricular roots.

Curriculum (n) - What schools teach; the combined experiences children undergo during schooling; a planned, sequenced series of experiences leading to ends that are sometimes known in advance and obtained with a maximum of teaching efficiency.

CHAPTER ONE

THE ART CURRICULUM: WHY?

During the 20th century, art teachers have benefited from and been victimized by the lack of a clearly articulated curriculum of study in their subject area. On the positive side, the lack of such a curriculum has provided a tremendous amount of freedom for art teachers. Upon entering their classrooms, most art teachers find that they can use their own creative abilities and higher order thinking skills to develop experiences in art not only tailored to fit the needs and backgrounds of their students, but also revolving around their own individual teaching strengths and artistic preferences.

Unfortunately this lack of curricular structure led to school art programs so individualized that they could be almost entirely unrelated to other subject disciplines and even to other teacher-made art programs on a school-by-school basis. Although often well conceived and educationally successful, such programs have traditionally been difficult to evaluate and/or justify to parents, peers, and educational administrators not schooled in the arts.

Educational Reform and Curricula in Art

Educational reform in America is cyclical. The cycle begins whenever the public at large pauses to take stock of the condition of education. It seems to me that reform tends to occur at 25-year intervals and ends whenever the populace turns its attention to other societal issues. Therefore, in addition to being cyclical, the period of reform is limited and usually lasts no more than 5 years. Although educational reform is often viewed with some degree of apprehension and skepticism by professional educators, there can be no doubt that, during the period of increased public awareness of and attention on education, a window of opportunity exists for educators to institute change in how the system is organized and what it includes in its curriculum.

From society's point of view, the purpose of educational reform traditionally has been to make what goes on in the classroom more powerful, more relevant, and more efficient. The American public has always turned to education to solve its problems. Our society wants schooling to be powerful, to set high standards, and to accomplish its goals. It wants schooling to be relevant and to impart knowledge integral to the continued growth and well being of individuals and their communities. Finally, the public wants education to be efficient and desires educators to devise the means to accomplish their goals as quickly, as completely, and as economically as possible.

The increasing level of cultural diversity in our country is adding to the perception that reform in education is critical. The U.S. has over 17,000 school districts, containing almost 100,000 schools. Despite recent calls for a move toward a national curriculum by such prestigious groups as the National Governors Association Task Force on Education, it is painfully clear that what works educationally in one school district may not be equally successful in another. American society is changing daily, and historically, schools have been asked to respond to society's needs. The apparent conflict between attending to the unique ethnic, cultural, and social values of various student populations while preparing all students to become active participants in and value the principles of American social democracy will continue to influence educational thinking and curriculum construction in all subject areas for the foreseeable future.

The current period of educational reform in this country has not been typical of most other such movements. First, this reform movement has already been in full bloom for 10 years (see the U.S. Department of Education 1983 publication *A Nation at Risk*) and shows no sign of abating anytime soon. Second, this movement has exhibited a strength of commitment by the public at large and correspondingly by public officials to look at every aspect of public education not just what used to be called "the basics." Clearly, those with a cadaverous, bare bones, "back to the basics" vision that sought to limit the scope of education to reading, writing, and arithmetic have yielded to a populace more concerned with what may be termed "basic education" (College Entrance Examination Board, 1985). The current move to restructure education has been predicated on teaching thinking skills rather than teaching facts. The attainment of higher order thinking skills (analysis, synthesis, and critical thinking) have been highlighted as basic aims of public education.

Perhaps for the first time in American educational history, tenets heretofore "written in stone" are being examined and re-examined. The very notion of cognition is being questioned as well as how to measure learning when broader notions of what constitutes thinking are applied. New or expanded definitions of cognition are coming into use that make a place for new measures of human intellect. As Eisner (1982, p. 29) noted, "A view of cognition that restricts thinking and knowing to forms of mentation that are exclusively discursive or mathematical leaves out far more than it includes." Thus, the trend is away from stan-

dardized tests that limited intelligence measurement to verbal and analytical skills and toward broader instruments that allow for individual differences and multiple ways of knowing and thinking (Gardner, 1983).

When broader notions of what comprises the human intellect are accepted, the design of the curriculum and the practice of teaching must also be revised. Thus, a recurring refrain of this education reform movement has been the term *integrating the curriculum*. The general educational curriculum, as it generally exists, tends to be fragmented and compartmentalized and, until recently, rarely have any attempts been made to develop significant linkages from one subject area to another. Therefore, schooling can be seen, at some levels, more as a series of discrete learning experiences rather than as a synthesis of related learnings from a wide variety of academic disciplines.

All of this is not to say that previous attempts have not been made to integrate the curriculum. They have and some of them have even been successful. But, for the most part, transfer of learning, the ability to apply knowledge gained from the study of one subject area in school to another has been difficult to achieve, let alone document.

Thankfully, South Carolina, my home state and therefore naturally a strong influence on my thoughts on curriculum, has been heavily involved in educational reform. In fact, for much of the past decade, South Carolina has been viewed as a national model for instituting positive and substantive change in schools. Even more importantly, improving the position art education occupies within the educational system has been, and continues to be, a major component of the educational improvement reforms our state has enacted. Art educators from many states have looked to South Carolina for guidance and leadership as they, too, attempted to improve the quality of their arts programs.

The South Carolina Education Improvement Act (EIA), the Arts Are Basic in the Curriculum grant (ABC) funded through the National Endowment for the Arts, and the South Carolina Department of Education Target 2000 grants have provided educators with the means to institute change, and change has been successful in our schools. Even during such fiscally troubled times as we have recently experienced, overall educational reform and reform in arts education have continued to move forward.

"Back to Basics" Versus Basic Education

As noted earlier, although there is still much contention, society at large seems to be moving away from the restrictive, "back to basics" movement of the late 1970s and early 1980s. People seem to be coming to the realization that increasing the amount of time and money spent attempting to teach children to read, write, or compute is not the answer. They are realizing that if "Jenny" and "Johnny" are unable to perform such basic tasks adequately, a wiser use of

resources and more successful techniques are needed. Funneling more time and money toward education will not help unless the approaches change.

Perhaps even more importantly, parents are becoming more demanding regarding the kinds of learning going on in schools. Instead of concentrating on information recall, comprehension, and application of knowledge (the three lowest forms of cognition in Bloom's [1956] Taxonomy of Educational Objectives), educators now are being asked to focus much of their curricular reform efforts on designing experiences that foster the acquisition of higher order and critical thinking skills by students and that make learning relevant and meaningful rather than redundant and boring. The latest and broadest theories and definitions of cognitive activity, typified by Howard Gardner's (1983) theory of multiple intelligences, reserve a place for the kind of thinking and problem solving that occurs when people have in-depth experiences with the arts. Definitions of higher level cognitive activity are being expanded to include the ability to feel, to respond, to appreciate, and to produce or perform in addition to being able to analyze, synthesize, and evaluate. (This will be covered in greater detail in Chapter 3.)

To maintain and even surpass the gains made in the field of art education during the past 15 years, art educators must convince society that (a) it is absolutely crucial for all children, not just those gifted in the arts, to be able to make, respond to, appreciate, and value the arts, and (b) art education can function as a "curricular collodion" that helps bind the general curriculum together into a cohesive, relevant learning environment.

As these global concepts of art education begin to filter into the mainstream, several related questions arise that provide much of the impetus for this book. These questions center around the importance of well designed and articulated art curricula as initial steps in extending the attitudes and beliefs we as art educators hold concerning the value of art in education to the general populace. They are:

- How can school art programs begin to interface with the rest of the general education curriculum without sacrificing their unique contributions to the development of the individual?

- How can school art programs communicate their educational worth to all of the concerned parties in the educational decision-making process?

- How can improvement in the ability to document learning in art be realized?

- Most specifically, how can issues of constructing curricula in art be dealt with so that the creativity, educational relevance, and academic freedom inherent in teacher-made curricula is retained while breaking down our isolation from fellow art teachers as well as the rest of the educational community?

- Finally, what must be done to provide concrete examples of how curriculum construction in art can begin to allow art teachers to address these issues successfully?

Can an Art Program Exist Without a Curriculum?

Section I begins with a quote from Senator Edward Kennedy's eulogy for his slain brother, Robert. The quote strikes me as having particular meaning for this book because it speaks to the function of visionaries and their collective positive attitude toward change. For many of us, change is difficult: It is upsetting, unsettling and always challenges the status quo. Change is about rearranging the current balance of power, and curricular change in art will be just as uncomfortable and unsettling to people in and outside of the field as change in any area. But it must also be acknowledged that change is perhaps the one constant in curriculum development. For in the final analysis, the process of creating a curriculum can never truly be considered to be finished. Just as American society continues to evolve within the context of what may become a global society, educational goals, constructs, and methodologies will continue to be adjusted accordingly.

This chapter also begins with three rather disparate definitions of curriculum. The first definition, "what schools teach," renders moot the question of whether one should have a curriculum. It seems that one cannot have school without having a curriculum of sorts. The question evolves rather into what kind of curriculum should there be to realize whatever benefits are possible from it. Therefore, the second and third definitions, "the combined experiences children undergo during schooling," and "a planned sequenced series of experiences leading to ends that are sometimes known in advance, and obtained with a maximum of teaching efficiency," relate more to the type, purpose, and specificity of the curriculum. Although these definitions initially may seem overly technical and too restrictive to be of much use, they may in fact be far more liberating for art teachers as we continue to strive for the means to create educational legitimacy for school art programs.

If art teachers in this country have one common complaint, it is that they feel isolated within the educational system. This educational isolation is real and can exist on many levels. Art teachers are often:

- **Geographically isolated** because of teaching schedules that force them to function as itinerant teachers with no physical place of their own in school. Rolling a cart from room to room or, worse yet, teaching art from the trunk of one's car does very little to engender feelings of empowerment, self-worth, and belonging among art teachers.

- **Intellectually isolated** from other teachers who tend to view them more as paraprofessionals or recreational therapists rather than as true educators.

- **Professionally isolated** from each other because rarely do schools contain more than one art teacher, and meetings among art specialists within a school district are often few and far between.

- And finally, **emotionally isolated** from educational administrators who, like most classroom teachers, also lack training in and, therefore, empathy for the arts.

This lack of knowledge in and empathy for the visual arts is certainly the cornerstone for the overall isolation art teachers experience, and it is clearly an area that can be significantly affected through the creation of a clearly articulated, conceptually oriented, sequential, multifaceted curriculum in art.

The forms an art curriculum can take and the concepts chosen for inclusion and emphasis are almost infinite. As noted previously, any attempt at constructing a "national curriculum in art" would be doomed to failure. Additionally, the aim of this book is to encourage art teachers to build upon two of their greatest attributes as they consider curricular questions, namely, their knowledge of art combined with their knowledge of the students to whom they must teach art.

In his seminal book *The Educational Imagination: On the Design and Evaluation of School Programs*, Elliot Eisner (1985) listed five forms of or philosophical orientations toward school curricula. A brief encapsulation of these orientations is presented here so that readers may begin to determine which form of curriculum is currently in place in their school/school district, and to pick and choose among them as theoretical "jumping off points" in their efforts to construct their own art curricula:

1. The Cognitive Development Curriculum. This curriculum seeks to emphasize process rather than content. Students are encouraged to learn how to learn. As such it is a problem-centered curriculum that places at its core thinking in the forms of problem finding and problem solving. Teaching the enhanced acquisition of visual perceptual skills and attempting to create experiences in art that explore visual problem-solving approaches to art education can be grouped in this category.

2. The Academic Rationalism Curriculum. This program of study attempts to foster the intellectual growth of the student by concentrating solely on those areas of knowledge most worthy of study. It seeks to isolate and present the very best ideas, the greatest works produced by humans. It concentrates on examining what is true, what is good, and what is beautiful. Defenders of this type of program's singlemindedness note that the absence of a common educational program serves to undercut social democracy. In recent years, works like *Cultural Literacy* by E.D. Hirsch (1987) are examples of this orientation. Those in art who feel that the masterpieces most worthy of study can be clearly identified and should form the basis of art curricula fall into this category.

3. <u>The Personal Relevance Curriculum</u>. This approach to designing educational experiences is based on shared governance and responsibility. The curriculum is created by teachers and children working together to identify things relevant to the child. This, of course, is the epitome of the child-centered approach in curriculum construction, and critics, although they acknowledge the high educational relevancy of the curriculum, question whether children know enough to participate in determining the curricular content of their education.

4. <u>The Social Adaptation and Social Reconstruction Curriculum</u>. Eisner's description here consists of two separate but closely related approaches to curriculum design. Social adaptation curricula are designed to be sensitive to the needs of society: Educational experiences are created that assist society in addressing its shortcomings. Based on this orientation, one could make the case that the American educational system is reactive rather than proactive and possesses little of the avant garde seen so often in the arts because it is so steeped in social adaptation. The inherent conflict between a proactive discipline like art and a reactive system like public education could be seen as a contributing factor to many of the difficulties art has had in achieving educational legitimacy. The fact remains, however, that whenever the American society collectively perceives a need in our country, public education is asked (required) to address it.

The social reconstruction curriculum is aimed at developing the critical consciousness of children so that they can focus on society's maladies rather than shortcomings with an eye toward alleviating them. An art curriculum based on either of these approaches would concern itself with current issues and trends; it would be topical and perhaps controversial.

5. <u>The Curriculum as Technology</u>. This theory is based on the assumption that all learning can be operationalized through statements referenced to observable behavior. The curriculum approach represents a technical undertaking that relates means to ends once those ends have been formulated. It should come as no surprise that this curriculum model is highly detailed, sequential, and behaviorally oriented. Quantifying learning that may be difficult to measure resides at the heart of this approach, and art curricula based on this approach are often created with evaluation and assessment driving the content of the program.

To Eisner's (1985) five programs, this author would like to suggest one more:

6. <u>The Amalgamated Curriculum</u>. This is, I feel, the most commonly found curriculum in America's schools. Simply stated, it is a combination of some or all of the previous five philosophical orientations. The amalgamated curriculum approach sacrifices philosophical focus by seeking to select the best facets from each of the other orientations and, because of

its lack of philosophical emphasis, effectively avoids criticism from those who might favor one or another of the previous five.

My own experience of 8 years teaching in the public schools and countless visits to school districts makes me think that you, the reader, have encountered, as I have, bits and pieces from several of these approaches in your own and other school or school district's general curricula. But even when taken in combination, as the sixth approach attempts, the school curriculum you work within is probably at best a loosely defined composite of these approaches. To further complicate the issue, the art program may or may not, for a variety of reasons, be required or even asked to support that amalgamous curriculum.

The reasons for the gap between theory and practice in the overall curriculum and the secondary gap between whatever curricular amalgam exists and the school art program are as old as curriculum theory itself. Simply stated, much of the disparity exists because what works in the laboratory or what looks good on paper often needs to be translated by teachers for it to be effective in the classroom. In terms of school art programs, much of the disparity exists because concerted efforts to align art with general education have been rare, and all too often, funding for curriculum construction and/or reform in art has been given low priority by educational leaders.

Curriculum Construction and Critical Questions for Art Education

This section restates in question form, expands, and answers the pivotal issues raised earlier concerning the purpose, creation, adoption, and potential educational impact of art education curriculum.

Q Can a convincing case be made that it is absolutely crucial for all children, not just those gifted in the arts, to be able to make, respond to, appreciate, and value the arts? Who, and at what levels, can make this case for the field?

A Those who only want children to be able to read, write, and compute want too little from education, not too much. Luckily, the clarion call in the 1970s for a "return to the basics" has yielded to an emphasis on what constitutes a "basic" education. In an increasingly competitive global society, our citizens must be able to think creatively, identify and solve problems, conceive of the unknown, see the world in new ways, interact with the environment, and utilize new technologies. Education in the visual arts can create new levels of visual literacy and generations of articulate spectators who can develop and employ spatial intelligence in their personal and professional lives.

Q Should art education function as a "curricular collodion" that helps bind (i.e., integrate) what has become an increasingly fragmented and disjointed series of experiences labeled the "general curriculum" into a cohesive, interrelated, and relevant learning environment?

A If art education is to achieve equality and educational legitimacy as a field, then art educators must seek to become an integral part of the academic arena. Art must be seen not merely as a form of recreational therapy or a break from the "rigors of schooling" but rather as a subject of study with a body of knowledge to be digested by students as well as an outlet for personal expression.

Q If the answer to the previous question is yes, how must we change school art curricula be changed to interface with the rest of the general education curriculum while maintaining school art programs' unique contributions to the development of the individual?

A By adding cultural contexts afforded by related artistic disciplines (aesthetics, art criticism, and art history) to the study of art, art education can help personalize and reinforce the entire educational process, thereby making it significantly more relevant to learners. By networking and articulating curricular goals on a district-wide basis, scope and sequence may be added to make experiences in art cumulative and conceptually meaningful.

Q How can school art programs communicate their educational worth to all concerned parties in the educational decision-making process so that all educational partners view school as the most logical place for all children to learn about art?

A For the most part, seeing is believing, and this adage holds true for school art programs. Curricular revision must be viewed as a grass roots or bottom-up process. Demonstrations of educational worth must be accomplished on a school-by-school and district-by-district basis until a "critical mass" of educational evidence can be documented. This constitutes research of the most basic nature.

Q How do art educators begin to improve the ability to document learning in art?

A Many educators and even some art educators view learning or performance in art as subjective and therefore difficult to measure or quantify. Some even feel that damage could be done to younger learners if their creative efforts were evaluated in any way. Recently, however, the concepts of assessment and evaluation in education have begun to undergo some serious reformulation. Time-honored ways of measuring cognitive growth are changing. Nationally normed, paper-and-pencil tests are beginning to give way before more personalized, anecdotal measures like portfolio assessment, self-administered check sheets, journal entries, and

group critiques at the end of assignments. In this area, visual arts programs have a distinct advantage over other academic disciplines because of their ability to discern cognitive growth and development from a wide variety of indicators.

Q How can art curricula be constructed so that the creativity, educational relevance, and academic freedom inherent in teacher-made curricula be retained without continuing to isolate art teachers from one another, let alone the rest of the educational community?

A First and foremost, no curriculum is "teacher proof." Instead of attempting to create a national curriculum complete in every way, which must merely be delivered to the students by the teacher, art educators should be concerned with personalizing or tailoring art curricula so that they meet the special and particular needs of the students of particular school districts. Also, many art teachers are talented curriculum planners. Working together in curriculum writing teams will empower them and give them a sense of ownership in the curriculum.

Finally, everyone must understand that the act of creating curriculum in any subject area can never be considered finished. The needs of students and the content of subject areas are constantly changing, and if curricula are to remain relevant, they must also change and grow accordingly.

Q What must be done to provide concrete examples of how art curriculum construction can begin to allow art teachers to address these issues successfully?

A Do not be overwhelmed by the amount of time and effort it takes to create an effective curriculum for the art program. Break the job of curriculum creation or curriculum revision into "bite sized pieces" by creating a district-wide art curriculum revision team.

The members of this team can review and then adapt (not adopt) currently available resources such as

- State curriculum frameworks.
- State and district curriculum documents.
- Nationally distributed textbook series.
- Packaged curriculum resources.
- Privately produced curricular resources.
- Perhaps most critical of all, teacher-produced instructional units.

Exhibitors at any state conference or national art education convention offer a variety of professionally produced products. Textbook series from other academic disciplines and study guides for any basic skills measurement programs

in your state can be examined so that, whenever possible, the art curriculum can sequence visual concepts, artistic media, and the study of art historical periods and themes with concepts being covered in other academic subject areas.

And the educational philosophy of the school district and any educational goals that pertain to the arts should be identified and incorporated in the district art curriculum. Pay particular attention to evaluation of learner outcomes.

Design ways for teachers to find out if the students are learning what was intended. It is best, however, not to become so embroiled with anticipated outcomes that provisions for assessing unanticipated educational outcomes are ignored.

Finally, share the results with others in and out of art education in a wide variety of ways.

CHAPTER 2

THE BASIC ELEMENTS OF AN ART CURRICULUM

Teaching involves planning in five critical areas: (a) identifying what children should learn; (b) selecting and classifying appropriate concepts and programmatic content; (c) incorporating suitable instructional technologies that allow the body of knowledge to be effectively and efficiently transmitted to students who may possess a variety of learning styles; (d) accounting for gender differences and diversity in cultural, social, and ethnic backgrounds; and (e) devising valid and appropriate ways to evaluate the outcomes of the educational process. Each of these areas relates to the other four, and often, in practice, the interrelationships can make them almost indistinguishable from each other.

This chapter will seek to treat each area individually before exploring how they relate to each other in the overall process of teaching art. In addition, this chapter will delineate and define several common elements that provide structure to curriculum in art regardless of the philosophical orientation of the curriculum itself.

Identifying What Children Should Learn

As the process of planning and organizing educational experiences for students unfolds, educators must first focus on what children should learn from studying art. This list of desired learnings or outcomes becomes the expected goals, aims, and objectives of the school art program.

Given the unique properties of art, not all goals or outcomes of art programs can be predicted. One of the most wonderful things about engaging in the creative process is that it consistently yields unforeseen learnings that occasionally may be more valuable than the outcomes originally predicted. Therefore, a place must be created that allows for all valuable and programmatically relevant outcomes, whether predicted or not. The expected goals should coincide

with the mission statement and/or curricular philosophy of the school or school district of which the program is a part. (*Note:* Six possible curricular orientations for schools and/or school districts were discussed in Chapter 1.)

Selecting Appropriate Content

Once the goals of a program are decided, appropriate content must be identified that directly relates to them. Initially, content for art programs should be broadly delineated. It should include concepts, contemporary and historical cultural contexts, themes, techniques, and modes of inquiry that are both uniquely germane to the study of art and serve to connect or integrate art to the general education curriculum. These "curricular constructs" should form the structure from which art teachers create learning experiences for their students.

Incorporating Suitable Instructional Technologies

Instructional methodologies, resource materials, first-hand interactions with art, and art-making processes must be chosen and/or created that provide the strongest and most efficient means of communicating the feelings, values, percepts, knowledge, information, and technical skills that have been deemed important enough to be included in the art program of study.

Instructional technology must not be thought of only in a "low-tech," mechanical way. Art teachers frequently have a reverence for both the traditional and the avant garde. Tools, procedures, and techniques that have survived centuries are often lovingly taught to students. Camel-hair brushes and manila paper have traditionally had a valued place in art curricula, along with the more recent additions of slides and large reproductions of art works. Over the next decade, however new, interactive instructional technologies already commonplace in school media centers will become increasingly more important to instruction. Art teachers will need to increase their comfort level with computers, laser discs, CD-ROMs, and CD-Interactive work stations. Knowledge not only of the creative, artistic applications computers offer will be necessary but also of the ways to retrieve the vast amounts of imagery, the corresponding information they contain, and interactive curriculum planning software progams specifically designed for art with be crucial.[1]

Accounting for Gender Differences and Diversity in Cultural, Social, and Ethnic Backgrounds

The fourth critical curriculum planning area involves accounting for the increasingly diverse nature of the members of our society when identifying content.

[1]See the *Curriculum Navigator for Art Series* by this author published by Dale Seymour Inc.

Teaching strategies should be designed that can address and validate alternate cultural, social, and ethnic value systems and differences in learning style due to gender.

Obviously, these issues are complex and require that curricula be tailored to fit the needs of individual school districts and even individual schools within school districts. However, it is best not to lose sight of what might be called "the over-arching values of our American social democracy" when attempting to address issues of multiculturalism.

Clearly, this is a question of balance in curriculum design. Art educational experiences celebrating each student's unique cultural, social and ethnic orientation must be balanced with experiences that celebrate America's shared democratic values.

Devising Valid and Appropriate Evaluation Techniques

Finally, the fifth critical area for devising appropriate art experiences is evaluation. Assessment and evaluation provide feedback to the teacher concerning how effective the program of study and instructional model have been in achieving the program's expected and unexpected outcomes. Evaluation can be preordinate or responsive. Preordinate evaluations seek to measure those outcomes that were expected while responsive evaluations attempt to assess those aspects of a program that could not be foreseen during the planning stages of curriculum development. Aspects of student evaluation and program assessment will be discussed in much greater detail in Chapter 9.

Interrelationships

As the reader may have already surmised, the relationships between and among goals and content, content and instruction, instruction and evaluation, and evaluation and goals are circular, unending, and never completely finalized. The curriculum can never be truly thought of as being finished or completed for the needs of the students and society are constantly evolving, thereby requiring the focus and direction of the curriculum to change accordingly.

In the real world, educational theory and practice seldom neatly coincide. What seems theoretically plausible can rarely be translated into practice without serious and substantial revision. Many school districts never effectively communicate their overall curricular philosophy or approach to their teachers. Often, the curricular orientation of the district is decided by the textbooks individually approved for each academic subject. Because each textbook series comes from different authors and publishers, a cohesive orientation to curriculum design becomes virtually impossible. Even when school districts do emphasize a unified philosophical approach to curriculum, they often fail to include the art program as an integral part of that approach and opt to treat art

as a break from the rigors of schooling or as recreational therapy for both students and teachers. All art educators have probably encountered well-meaning school administrators who unwittingly undervalue art education by thinking of it solely as part of an enrichment program that, when teamed with music, physical education, and weekly visits to the school library and computer lab, exists as an opportunity to give the "real teachers" a planning period.

It should be of little surprise, therefore, that while art programmatic goals, aims, and objectives have sometimes been clearly delineated and included in the general education curriculum, more often than not, they have resided as barely articulated notions or "givens" which every art teacher knows from training and experience as educational truisms. This chapter begins with a stanza from a popular song by the Eisley Brothers. "It's your thing. Do what you want to do." This typifies the condition of the art curriculum all too often in our schools. For the isolation art teachers feel in schools extends into the curriculum they are individually required to construct. At present, the major unifying forces in curriculum construction in art appear to revolve around a desire to place the child at the center of art programs and a reliance on a study of formalism as the undergirding framework upon which to design art experiences.

Integrating the Parts of the Curriculum

Regardless of whether art curricula are clearly written and delineated, the components are familiar to most, if not all, art teachers. After all, teaching art to hundreds of students per week, in several schools, from the trunk of one's car, places organizational demands on the art teacher that most other teachers never dream of, even in their worst educational nightmares.

Initially, art program goals should be identified by applying the philosophical orientation toward curriculum that the school or school district chooses to employ in the field of art. Content for the art curriculum, therefore, can be gleaned from those areas where the study of art can reinforce or advance the overall curricular orientation of the school. Content should also be collected from a variety of complementary sources, inside and outside the discipline of art, as curriculum writers and art teachers continue to refine and elaborate upon their original framework of expected outcomes. One of the most valuable sources of information for identifying appropriate and relevant curriculum content comes from attempting to assess the educational needs of the student body. Conducting formal and informal needs assessments helps curriculum developers recognize gaps between the here-and-now situation and the desired outcomes of education (Unruh & Unruh, 1984).

Goals or aims were defined earlier as the expected student outcomes to be realized by studying art. Objectives can be thought of as "mini-" or intermediate goals that assess student progress toward the more global desired outcomes. In other words, goals are major programmatic outcomes while objec-

tives are small, usually measurable steps that lead toward accomplishing goals. It has also been noted that not all outcomes of an art program can or should be predictable due to the unique nature of the problem-finding/problem-solving process in art and the structured but open-ended approach employed by art teachers. When unexpected outcomes of value occur, art teachers must be able to recognize and cherish such learning as they seek to evaluate student growth and development (Stake, 1975).

Three other curricular terms must be taken into account as the curriculum continues to unfold. *Scope* relates to the extent and depth to which content is covered. Concepts must often be introduced at basic levels appropriate for young children and reintroduced later in more sophisticated ways. *Sequence* provides an order for educational experiences which seeks to anchor current learnings in past experiences. In general, sequence should not be applied too rigidly because many factors can influence the order in which concepts should be presented to learners in art. Individual learning style can be a confounding variable that makes choosing the sequence of learning activities more problematic than one might ordinarily assume. However, suffice to say that when planning curricula, a given number of concepts can be assigned to a grade level and then left up to individual teachers to order according to their first-hand knowledge of their students.

Instruction involves the teacher as a motivator/facilitator. What is sometimes referred to as the "art of teaching" requires that the art teacher be able to translate the content of the curriculum into a series of interesting, relevant, and understandable learning experiences for each student while taking into account individual differences and learning styles. Instructional methodology, therefore, is the process of communicating and modeling feelings, percepts, intuitions, qualities, technical skills, and facts that lead in the words of noted music educator Bennett Reimer (1990) to "knowing how" (creative self-expression/art production), "knowing of" (aesthetic perception), "knowing about" (art history/cultural heritage) and "knowing why" (aesthetic valuing).

Articulation of the curriculum requires that all of the educational partners responsible for the development of the child be informed as to the goals of the art program. More specifically, and importantly, articulation refers to consensus building and teamwork among the school district's art teachers. When curriculum is determined by individual art teachers working in isolation from each other, articulation is nonexistent. This situation increases the risk of children being subjected to redundant information and instruction in art. Articulation of the curriculum, however, allows teachers to avoid duplication *and* integrate the art program with other academic disciplines

Theoretical and philosophical consensus among school art curricula writers is the necessary prerequisite to creating a document that possesses both content validity and personal relevancy. Once consensus is reached, art curricula writers can turn their attention to the pragmatic necessities of translating theory

into practice. At this point, addressing such issues as skill development, readiness, and self-image become crucial to the curriculum developer. The content of the curriculum must be married to learning activities specifically designed to transmit that content to learners.

Most of what has been discovered about good teaching practice revolves around teaching behaviors or strategies that focus on making learners active participants in the educational process. It is often unclear why some children seem to "toss in the towel" and give up on schooling early in their formal education. Most of these "mental dropouts" learned to walk, talk, and even draw before they came to school. Why then do they give up in school? John Dewey (1934) noted that children could not be treated as miniature adults, that they learned best from first-hand interactions with the world around them: Children perceive the world through their senses, make hypotheses when encountering new things, test these hypotheses, accept or reject them, and add this new information to their growing repertoire of knowledge. When attempting to learn complex cognitive or physical skills like language or walking, often this process involves hundreds, if not thousands, of unsuccessful attempts before the desired results are achieved. Sometimes I think that if preschool children reacted to failure and frustration the way school children do, none of them would ever learn to walk or talk, let alone draw at even the most rudimentary levels.

Currently, art is one of the few subjects in school where children are encouraged to retain and utilize the active, first-hand learning strategies they employed so successfully before they came to school. Perhaps this is one of the main reasons so many young children list art among their favorite school subjects. Instead of being asked to "sit still, fold your hands, and listen," children are asked to learn through their senses and by combining multiple ways of knowing. They are asked to accomplish these formidable tasks by interacting with a wide variety of visual and written materials and solving an almost infinite array of visual problems.

Therefore, as the curriculum evolves from the broad strokes laid down by choosing an educational philosophy and appropriate learning theory, the specific aims or objectives of the curriculum revolve around using active learning strategies to provide the means for every student to be successful in acquiring the ability to create, respond to, understand, and appreciate art. What may be called the intermediate aims and objectives of the curriculum include

- Developing cognition in its broadest forms.
- Enhancing visual perceptual skills.
- Augmenting verbal skills.
- Honing fine and gross motor control.
- Providing for individual differences in social, cultural, gender, and learning styles.
- Encouraging children to develop a level of technical mastery and control over the materials they are asked to manipulate.
- Allowing children to express themselves visually, verbally, and in written form in ways that are meaningful to them.

CHAPTER 3

THE THEORETICAL FOUNDATIONS OF CURRICULA IN ART

Exploring Art's Curricular Roots

The history of art education in this country is clearly connected to the aims and goals of public education and society's tendency to use schooling as a vehicle for addressing its needs or shortcomings. From the days of Walter Smith and the Picture Study movement in American art education to current practice, the curriculum has been formed, at least in part, with an eye toward turning today's students into tomorrow's citizens and workers. In other words, a major aim of our system of public education has been and continues to be to produce individuals who value and appreciate democratic principles; make informed, rational decisions; and contribute to the continued growth and development of our way of life. From generation to generation education has been viewed as a means to achieving a better way of life intellectually, socially, and economically.

Specific events and movements have also influenced education curricula. For example, when the Industrial Revolution was in full swing, public education stressed not only the literacy skills necessary to create an informed electorate, but also the drawing skills thought to be important so that ideas for new machines and inventions could be drawn on paper prior to being constructed. During this period, the content of art education reflected this need for draftspeople who could translate ideas into schemata (blueprints and plans) that could then be constructed by craftspersons.

Later, the adoption of the scientific method as the major means of investigating virtually any question or problem and the emergence of psychology as a field devoted to the study of human needs and behaviors also began to leave their marks on the educational process. Taken together, these two occurrences have done much to determine educational theory and practice in general, and art education theory and practice in particular. Today, much of the content of general education and art education curricula is based on promoting American

values and aspirations that adhere to the "American dream" of getting an education and working hard to better one's social and/or economic condition. And many educators can bear witness to the effects of applying the scientific method to designing educational experiences for children and to attempting to measure the educational outcomes sought.

Even as a social or "soft" science, psychology has also employed the scientific method whenever possible. Dealing with humans, however, has limited psychology's methodology, because human subjects cannot be treated the same as nonhuman or inanimate objects. The phrase "Above all do no harm" from the Hippocratic Oath guides psychologists and educators as much as it does doctors of medicine. While respecting the value and uniqueness of human life, behavioral psychology still seeks to investigate the ways in which humans develop the abilities to think and learn. Educational psychology, an outgrowth of behavioral psychology, strives to create appropriate teaching strategies for educators. Learning theories are posited, and the behaviors children exhibit are used to measure educational outcomes.

Perhaps more than the members of any other academic discipline, art educators have believed in placing the child, not the subject, at the center of the curriculum. The importance of nurturing human development and developing individual creativity through artistic activity have long been recognized (Dewey, 1934; Lowenfeld, 1947). In doing so, art educators have utilized the formal qualities of art, the elements and principles of design, as the conceptual underpinnings for student learning experiences. In essence, we have believed, and continue to believe, that "art vivifies life" (Eisner, 1972) and that humankind's greatest accomplishments are embodied in it.

Let me emphasize that there is much to be commended in this approach. The very fact that art education has survived, and in some places prospered, in today's woefully underfunded educational system, gives much testament to the value and educational worth of well conceived child-centered approaches in art education. It is correct to place the well being of the child squarely at the center of the curriculum. In fact, the field of educational psychology and the theories of the father of our field, Viktor Lowenfeld, himself a psychologist, are devoted to supporting this issue.

Lowenfeld's (1947) theories posited that the process of interacting with art materials would allow children to work through emotional, maturational, and even creative problems, eventually resulting in their becoming fully differentiated or integrated adults. For him, the process of interacting with art materials was a means to this end and the art product was of secondary consequence. Many of Lowenfeld's students, however, were wedded first and foremost to art, not psychology, and have extended his vision to include the art product as an important goal or end of the art program. A careful review of art curricula shows that many of today's art programs have been designed to emphasize the production of art and use the studio artist as the major, if not only, artistic role

model for children to emulate. To provide examples of that role model in action, art educators have successfully included works from the "real" or adult world of art in school art programs. Art teachers realized early on that exposing children to works of art from the adult world of art would not stunt their creative or emotional development but rather enhance it. Herein lies an excellent example of an educational theory that has been extended or evolved through application in actual classrooms.

Behavioral psychology also has played an integral role in the development of art curriculum. The past 50 years have witnessed a virtual explosion of the influence of the scientific method on curriculum construction in all subject areas. In essence, psychology not only has been employed in identifying appropriate methods of teaching but has extended its influence into curriculum content as well. For art educators the educational assumptions are all too clear: If certain forms of learning are resistant to being quantified through some manipulation of the scientific method, then perhaps that learning does not exist. Or if it does, then perhaps it is of an educationally marginal nature. Reimer (1992) has noted that this practice or assumption seems unsound because educators should look to psychology for method and to philosophy for content.

In fact, the preceding discussion of historical influences also functions as a brief history of the major rationales art teachers have used to justify their existence as part of the public school system (Lanier, 1981). Unfortunately, these rationales have yet to consistently yield the educational legitimacy sought for the field. As noted earlier, there are many signs that this current period of educational reform is very different from previous attempts to change the system. If the era of "behaviorism" is truly ending in public education, then perhaps opportunities to redefine general education to include a significant place for the arts really do exist. If they do, then the development of significant, substantial curricula in art will do much to provide evidence of art's educational worth.

Theories Contributing to Artistic Development

During the years, art education has borrowed heavily from the research and practices of other fields, namely, cognitive and behavioral psychology and learning theory to formulate its beliefs and practices. To name just one of many possible examples, the child-centered or creative self-expressive movement has its roots in the theories of child development (Dewey, 1934; Lowenfeld, 1947; Piaget, 1970). Historically, the field has developed rationales for art education by synthesizing and adapting the theories previously mentioned. Some of art education's finest scholars have drawn the connections between art education and these related fields. Eisner's (1972) foundational work *Educating Artistic Vision* is a virtual encyclopedia of theories and adaptations of theories. In drawing from other fields, art educators have attempted to use art experiences to enhance visual perceptual skills, creativity, critical thinking, and problem solving and to foster higher self esteem. Cultural and anthropological influ-

ences on artistic growth and development have been explored (McFee, 1961). Even the physiological division of the human brain into right and left hemispheres has been used to make the case for art's ability to educate the "right side of the brain" (Dorethy & Reeves, 1978; Edwards, 1979). More recently, art research has begun to draw connections to newer research coming from the broader definitions of cognition being proposed by contemporary cognitive scientists. Bloom's Taxonomy (1956), which divides the intellect into three domains (Cognitive, Affective, and Psychomotor), is beginning to be extended by contemporary theories of multiple forms of intelligence like the one posited by Gardner (1983).

For the first time in educational history, rational thought, (Bloom's Cognitive Domain) and emotion (Bloom's Affective Domain) are no longer seen to be at opposite ends of an intellectual continuum. It is quite significant to examine how "loaded" our language has been in describing what it means to have an emotional response to any given object (like an artwork) or situation. If someone is said to be emotional, by definition they are not functioning in the cognitive domain and, therefore, not employing rational thought. In short the assumption has been if one is not rational, one is not thinking. How much this assumption has contributed to the marginal position art education has occupied in the educational system is difficult to estimate.

However, as the chasm between feeling and knowing closes, and the definition of what cognition means broadens, it is becoming possible for art educators to make the case that *feeling equals knowing*. It becomes possible to say that when someone possesses the capacity to feel or react to an object, person, or situation then that someone knows about that object, person, or situation in a way that a totally dispassionate (rational) person does not. Broudy's (1972) phrase, "Feelingful knowledge and knowledgful feeling" has never been more apt. Herein may lie the single most important educational construct for art education to base its curricular reform on for the foreseeable future. If feeling does equal knowing, if there are multiple forms of intelligence such as linguistic, logical-mathematical, spatial, musical, bodily-kinesthetic, interpersonal, and intrapersonal (Gardner, 1983), then art must occupy a significant place in the educational system if that system is truly dedicated to exploring and developing the human intellect.

Imagination is more important than knowledge."
 - Albert Einstein

SECTION TWO

APPROACHES THAT WORK

Chapters 4, 5, and 6 define the components of several successful approaches to constructing art curricula based on the six philosophical orientations identified and discussed in Chapter 1.

The discussion will begin with an analysis of a traditional, child-centered, creative self-expressive approach in Chapter 4. Chapter 5 examines a social adaptation/social reconstruction model and an integrated arts model. This section concludes with Chapter 6's look at a multifaceted, cognitive development model, an academic rationalism model, a curriculum as technology model, and finally, the amalgamated curriculum approach.

""In the end, you can never rise above fantasy."
- C.G. Jung

CHAPTER 4

BUILDING ON THE PAST

In the previous chapter some space was devoted to making a case that educational theories often change when they move from theory to practice. Even the most accepted and successful approaches to teaching art have changed or been extended over the years as practice continues to inform theory. In point of fact, much of what we have traditionally sought to accomplish through school art programs has been realized. All across this country there are examples of art programs that have become integral, institutionalized parts of the educational process. Unfortunately, these examples seem all too few in number. In addition, in virtually every example of a successfully implemented art program can be found evidence of superior leadership from one or more art teachers, leadership that has educated and motivated school board members, administrators, teachers, and students concerning the value of art in education. Unfortunately, if the leaders in such a school district take another position, retire, or move on for whatever reason, the art program often experiences a serious decline in support.

This tells us two things. First, training leaders deserves serious attention in undergraduate and graduate art education teacher training programs. Second, a key component is missing in providing continuity and purpose in art programs. That component is, of course, a well articulated curriculum. Obviously, the second item, not the first, is the underlying reason for this book. (For a more thorough discussion of developing leadership in art teachers see "Leadership and the Art Specialist: Twenty Ways to Improve Your Program's Position in the Educational System" [Dunn, 1992].)

Traditional Approaches to Designing Art Curricula

Traditionally, most art curricula have (a) attempted to foster individual creativity by being child centered and (b) been founded upon studio experiences that emphasize the elements and principles of design (Dunn 1986, 1987). These are laudable goals for a school art program. Who would, or should, argue with placing the child at the center of the educational model? And, as far as the ele-

ments and principles of design go, when art teachers are asked to list the concepts they teach in art they almost uniformly respond with a chorus that begins with "line, shape, color, texture...".

These then, are foundational concepts that need to be explored and analyzed with students. In my mind, they function much like the parts of speech of the English language. They provide structure, an undergirding framework for the creation and analysis of art. However, like the parts of speech, they are a beginning, not an end in and of themselves.

Students know how to speak in sentences before they come to school. They may not know the labels for nouns, pronouns, and verbs but they know how to use them. Similarly, students know how to draw and paint before coming to school, if they have had opportunity to interact with these media. They may not be able to define line or shape or texture, but they know how to use them too.

So, traditionally, curricula in art have placed the development and well being of the child first, utilizing experiences that teach the "language of art" as a means to nurture a child's creativity and artistic talent. These programs have been predicated on the belief that students need to recognize, perceive, understand, and be able to use the elements and principles of design in their own works of art and, more recently, in the works of other artists. In concert with these elements and principles, the vast majority of art curricula have traditionally emphasized interaction with artistic media to the virtual exclusion of any other activity and have employed a breadth-versus-depth approach when it comes to exploring artistic media.

Over the years, instruction in art has evolved from a rather hands-off approach in which the art teacher was encouraged to limit his or her teaching to motivating, encouraging, and nurturing students to a more proactive teaching approach. Today, the art teacher usually actively intervenes through techniques such as demonstrations of appropriate studio techniques and discussions/critiques of student and adult works of art.

However, for some art teachers, curriculum construction in art consists of merely completing an inventory of available supplies. I often tease art teachers when I speak to them by telling them that I have a vision of art teachers, 50,000 of them across the country, all getting up half an hour early on trash day so that they can "cruise the neighborhood" to see if there's anything worth taking to school. I sometimes feel that the almost subconscious desire to teach every medium in every year of school is a reaction to the minimal amounts of time art teachers have with children. In a desire to maximize children's experiences in art art teachers sometimes fall into the trap of trying to squeeze it all in. Time for even the most rudimentary student experimentation with materials is almost nonexistent. Students are often confronted with materials that they have rarely or never seen before and then asked to make a completed work of art within 45 minutes.

In many cases, it seems as though the media to be covered virtually dictate the concepts that get taught, rather than the artistic or aesthetic concepts dictating the appropriate media to be utilized. If the planning books of 20 different elementary art specialists were appended to this chapter, chances are there would be an amazing, and perhaps disturbing, similarity in how lessons or even units of instruction were listed. Notations like "First Grade-Painting," "Second Grade-Found Object Prints," and "Third Grade-Contour Drawing" would be all too common. Years ago, futurist, Marshall McLuhan (1967) captured the public's imagination with the phrase, "The medium is the message," and in many school art programs, nothing could be more accurate.

After years of dominance by the child-centered approach, its most telling shortcoming seems to be that it served to limit the academic content of the art program. Art programs were seen as educational fluff or as a break from the rigors of schooling, rather than as contributing to the cognitive development and knowledge base of children.

Increasingly, many child-centered art programs have extended the "Lowenfeldian model" by making a place for the adult world of art as exemplars worthy of study by children. By doing so they have made significant moves toward strengthening the content of the art program. Curriculum planning in child-centered art programs has broadened to include more art criticism, art history, cultural information, and methods in art that encourage the development of critical thinking skills. The term *visual problem solving* has emerged as an educational construct that clearly falls within the purview of child-centered art programs seeking to develop and enhance levels of visual literacy in students. In short, concepts, principles, and constructs in addition to the elements and principles of design have been added to the curricular mix of high-quality child-centered school art programs. While the child remains paramount in these programs, the discipline of art has evolved into more of an equal partner. Herbert Read's (1956) famous art education rationale, "Art for art's sake," serves to highlight that the highest achievements of humankind are contained in the arts and that for this reason alone art is an academic discipline that deserves a place in the school curriculum.

It has always seemed strange to me that art was the only subject in school invested with responsibility for the child's mental, emotional, and creative well-being. While this is certainly an outcome of the promotion of art as a therapeutic part of the educational system during the 1930s and 1940s, it is a heavy burden for a subject area to bear. Perhaps the most important outcome demonstrated by the child-centered art movement over the past 50 years is that *all good teaching is child centered*. This is a fact that we will continue to note in later chapters as we look at other approaches to designing curriculum in art.

The relationship between government and art must necessarily be a delicate one. It would not be appropriate for the government to try to define what is good or what is true or what is beautiful. But government can provide nourishment to the ground within which these ideas spring forth...

- Jimmy Carter

CHAPTER FIVE

CURRICULUM AND CULTURE: PLACING ART IN A SOCIAL CONTEXT

Current Issues

New Definitions for Student Learning

Chapter 1 briefly touched on some general aspects of this country's current educational reform movement. Reform is topical, it involves addressing current issues and trends in education. When attempting to place art curriculum in a social and/or cultural context, it makes sense to return to the topic of reform as a basis for beginning the discussion.

During most of the past decade and still continuing, the entire educational system has come under close scrutiny. Those who are partners in the educational process—parents, teachers, administrators, school board members, and even elected officials—have called repeatedly for a revitalized educational system that makes schooling more efficient, more holistic, more relevant, and less compartmentalized.

As already noted, as reforms have been implemented and assessed, educational leaders have begun to appear ready to entertain new and broader definitions of what constitutes intelligence and cognition and what contributes to their development in children. Many who are actively involved in educational reform movements have called for a reduction in their system's reliance on standardized tests, written exams, and other traditional assessment strategies as the most viable way to measure such complex educational outcomes as knowledge and cognitive growth in an individual.

Cultural Diversity

The issues educators currently face are more varied and perhaps more critical than any previous ones. Increasing levels of cultural diversity, socioeco-

nomic disparity, and gender issues place many students "at risk" (of dropping out of public education). Plus, I wonder how many have dropped out mentally, even though they still attend school. There can be little doubt that many of the issues currently facing art education are the same ones challenging the entire educational system. Interestingly enough, many times these issues seem almost diametrically opposed to or mutually exclusive of each other, and as yet, no clear answers seem forthcoming.

Addressing the increasing level of cultural diversity exhibited by America's students heads the list of pressing issues followed closely by such related concerns as designing curricula that are gender neutral, determining if a national curriculum is desirable let alone achievable, and creating and implementing culturally unbiased assessment measures that provide an accurate measure of academic achievement.

As society becomes more culturally diverse, the verbal and visual languages spoken in the schools multiply, and the students' cultural values become more and more disparate. The image of America as a vast cultural "melting pot" has yielded to a truer analogy—the American cultural "tossed salad." Designing experiences that allow students to cherish and build upon the cultural values of their heritage while learning tolerance for the values of others and then developing the shared beliefs necessary for our nation to maintain its purpose and identity pose huge educational problems for today's teachers. Even achieving gender equity—structuring educational experiences so that they accommodate the learning styles of both males and females and turn away from educational stereotypes that limit the aspirations of students because of their gender— seems almost impossible for the traditional school system to address successfully.

In the arts, the move from one era, modernism, to the next set of artistic constructs and beliefs, postmodernism, is causing many to restructure what is taught and how to teach it. Ethical issues relating to the role teachers should play in the emotional and moral development of their students can be contrasted with academic freedom issues revolving around censorship and ways to balance programmatic content. The values that some may see in an art program may clash with those held by community members, another cause of concern in art education with no ready solution.

Social Adaptation/Social Reconstruction Models

As our country becomes more and more culturally diverse, the curricular approaches encompassed by the social adaptation model offer a philosophical foundation for developing schools sensitive and responsive to the needs of all members of society. The educational experiences chosen for a social adaptation approach to curriculum design are included precisely because educators feel that these learnings will ultimately help society address its shortcomings. As noted in Chapter 1, however, this is a somewhat reactive approach designed to follow the dictates of the community, whether at the local, state, or

even national level. If the directives that the schools receive from each of these "partners in education" are accurate and timely, then schooling achieves a level of personal and social relevance that other curricular models may lack.

One, and perhaps the major, potential shortcoming of this approach lies in the fact that it depends upon the continued interest of many outside entities for direction. If any of these educational partners turns its attention to other matters, then the social adaptation approach can begin to stagnate and lose the ability to evolve effectively as the problems confronting the society change. Unfortunately, the history of American education is replete with instances when major players in the creation of educational policy have turned to other, more compelling, issues and let education drift in what could well be seen as a vacuum of leadership.

On the other hand, the social reconstruction approach to curriculum design is much more proactive—some might even say radical—because it places responsibility for identifying society's ills and training students to act to alleviate them in the hands of local educators (school boards, administrators, and teachers).

In this approach, educators, including teachers, are truly empowered: They are given the responsibility of making and keeping schools relevant by teaching for societal and cultural change. In such circumstances, teachers are encouraged to draw information from a wide variety of historical, cultural, anthropological, social, and ethnic sources to examine "what is" and encourage students to work toward "what could be."

Obviously, either of these curricular approaches could be used to effectively address the problems encountered by a multicultural society, or even to create a global curriculum that goes far beyond the scope of a "hyphen American" orientation. The limitations that face these approaches should not be underestimated. They both depend on a society ready for schools that actively seek to promote societal change and, on a much more pragmatic level, on the availability of teachers trained to plan for such a curriculum and the classroom resources necessary to provide the content.

How, you may ask, can school art programs fit into a model that seeks to examine and address society's maladies? Perhaps better than one might think at first glance. For the visual arts provide a tangible record of every culture and society we may wish to examine in school. They provide insight into the values, successes, and failures of every society or culture from which they emanate. They are the very essence of humanity and can be used to both illustrate and examine the cultural conflicts and confluences that occur in our own American microcosm of the global society.

To be sure, the problems of teacher training and the production of suitable classroom resources persist. However, more and more art teachers are entering their classrooms with a broader notion of what should be included in school art programs, and the number of multicultural resources being produced by educational publishers has increased dramatically in the 1990s.

Integrating the Arts Model

Historically, balance and equality have been lacking whenever attempts have been made to integrate different subject areas. During the late 1960s and early 1970s (the previous era of educational reform) there was a proliferation of humanities programs at the secondary school level that tried to marry such disciplines as art, music, history, and literature. Unfortunately, rather than being asked to function as equals, art and music were often used as the "sugar coating" that made the history/literature pill easier for students to swallow. Even today art and music are often included in gifted and talented programs more for their popularity with students than for their contributions as disciplines that each contain a body of knowledge in itself worthy of serious and prolonged study.

Perhaps it should come as no surprise that traditional academic heavyweights like history and English literature were emphasized in humanities programs. Perhaps the arts were too optimistic during the last period of educational reform in trying to compete for equal billing during a time when cognition was so narrowly defined. But, given the current recognition in American education of a broader definition of cognition, perhaps now is the time for a new venture in integrating the arts in education.

A Proposal

An important component of the educational reform movement in visual arts education during the past decade has been the emerging sensitivity of arts educators to expanding the art curriculum to include content from the four disciplines of art (Clark, Day, & Greer, 1987). In many schools, multifaceted art programs have been created that elevate the arts from soft, semirecreational, quasitherapeutic respites in the school day by fostering multiple forms of perceiving, feeling, and knowing while simultaneously providing opportunities for self-expression and transmitting a body of knowledge about art.

Not all schools have attempted to achieve or been successful in achieving a rigorous arts program, and with good reason. They are difficult to achieve under the best of circumstances. When students spend less than 2% of the school week studying art, as is the case in many schools, it becomes virtually impossible. Even in states and districts that are highly supportive of arts education, the need still exists to make arts programs more powerful, relevant, and efficient.

For most American students, the last time they are required to study any form of the arts is in middle school. Therefore, middle school presents an opportunity lacking in secondary school—that of reaching virtually all students. During middle school, many students receive art for one quarter and music for another, or some variation on this model. Some also receive dance in their physical education programs, and a very few receive drama. Even though a clear balance among these four school art forms does not currently exist, nev-

ertheless, middle schools possess the resources, the staff, and the opportunity to attempt to integrate the arts with each other.

Creating an integrated arts program in the 1990s would effectively sidestep the problems that marked the humanities programs of the 1960s and 1970s because each of the arts would be more clearly bonded to each other and could complement and reinforce each other rather than compete for student attention. There is a shared terminology and respect for feeling as a way of knowing that may not be so clearly articulated in other academic areas. Finally, each of the art forms shares the same four disciplines: art history, art criticism, art production/performance, and aesthetics. These could be used to draw the curricular linkages so often missing in American general education.

Putting Theory into Practice

Where would such an integrated arts program draw its resources? How would it be organized? How much would it cost? My proposal for creating an integrated arts program at the middle school level would have the pragmatic advantage of making the best possible use of current staff and resources. Such a change would, therefore, minimize cost increases and, I believe, be acceptable to educational decision makers not only during a period of educational reform, when funding for such initiatives is available, but also during those long years between periods of reform.

To be successful, this integrated arts program must first be based on a team-teaching approach that utilizes the expertise of trained specialists in art, music, dance, and drama education. Currently, middle schools in virtually all states employ specialists in art, music, and physical education. Many physical education majors have strong backgrounds in dance. At some point in the not too distant future teacher certification in dance may become more common than it currently is. But until then, we should seek to make use of the expertise physical education instructors currently offer. Drama is also not adequately represented at the elementary and middle school levels, but until drama specialists become more prevalent, creative writing could be substituted for drama particularly if significant time was spent in the class studying, writing, and performing plays.

How would such a program be organized? Instead of attending art every day for 6 to 9 weeks and then switching to music for the same amount of time, then drama and finally dance, students would attend art, music, dance, and drama for a double period on four successive days each week for an entire semester. On the fifth day, students would meet with all four arts teachers in a large group (see Table 1). Thus, the total length of the program would remain the same as many current separate arts programs, one semester, and the staffing, with the exception of drama or creative writing, would also be the same. The major differences occur in the fact that the team-teaching approach allows the arts teachers to plan together and reinforce the learning experiences children encounter in the separate arts days. Opportunities for developing the abilities to

respond, produce or perform, appreciate, value, and create a cultural/historical context for *all* the arts then become attainable.

Table 1
Middle School Integrated Arts Courses Meeting for 18
Rather than 6 to 9 weeks

Periods 1 & 2	Monday	Tuesday	Wednesday	Thursday	Friday
Class A	Art	Music	Drama	Dance	Classes A-D Arts Team Lecture
Class B	Music	Drama	Dance	Art	
Class C	Drama	Dance	Art	Music	
Class D	Dance	Art	Music	Drama	

Content for the integrated arts program could be drawn from the four artistic disciplines and sequenced so that themes, concepts, styles, cultures, and periods being covered in the visual arts would also be covered and reinforced in each of the other arts and vice versa. What is studied in art is also studied in music, dance, and drama. The cultural, critical, social, historical, and aesthetic implications of such in-depth study are enormous compared to the piecemeal way in which the arts disciplines are currently covered.

At present we can only guess at how much more powerful and efficient an integrated arts programs would be. But the thought is enticing of middle-school students studying the works, mastering the techniques, and examining the aesthetic beliefs of the Impressionist painters while listening to and performing music from the same era, seeing and dancing the ballets and folk dances of that time, and reading and performing excerpts from that era's literature and drama.

Indeed, how much more relevant schooling would become if an equal amount of time and effort was spent in exploring the culture of Native Americans or African-Americans through an in-depth examination of their art works while listening to and performing the music they played, seeing and

dancing the tribal and folk dances that were part of their ancestors' everyday lives, and reading and performing excerpts from the oral histories passed down from generation to generation by members of these or many other American and non-Western cultures.?

As was noted earlier, school arts programs have been based on gifted and talented models of education. Traditionally, children who could produce or perform were encouraged and those who appeared to be less physically or overtly dexterous were discouraged. In short, school arts programs too often have tended to concentrate on developing the gifts of a talented minority rather than creating a broad cross-section of arts connoisseurs. Arts programs have suffered accordingly. Integrating the arts could well begin to reverse this trend by providing multiple opportunities for achieving success while studying the arts. New avenues for success could be uncovered that go beyond producing or performing.

Finally, if this vision for an integrated arts program seems overly broad or lacking clarity or definition to the reader, I must in part agree. These musings are meant to stimulate, not prescribe. There is no one right way to achieve the kinds of aims placed before you in this brief narrative. One can not and should not attempt to "teacher-proof" a curriculum by creating a curricular cookbook bursting with can't-fail teaching recipes. Teachers must tailor their curricular, as well as pedagogical, efforts to meet the needs of their students, and the approach outlined here is an attempt to encourage the kind of unified thinking and curricular bridge-building so desperately needed in the American educational system. Integrating the arts can accomplish two vital goals: Arts programs can serve as a model for the rest of the curriculum (as is currently the case in the evaluation and assessment areas) and thereby enable arts educators to participate significantly in the restructuring of general education with the arts at its core.

Integrating the Arts with the Rest of the Curriculum

Historically, the arts in education have not been equal partners in the educational process. Perhaps the leap from frill to essential, from fluff to requirement, was simply too great a vault for any one curricular area to make. However, if the arts are successfully integrated with each other, then it becomes possible to document that they possess the academic relevance and intellectual discipline to merit full partnership in the educational system. The question for us as individual art teachers and as a field, therefore, is not simply how do we get better at doing what we do? But rather, what must we do to move our field into the educational mainstream? As efforts to refine and strengthen the school art curriculum continue, integrating the arts certainly merits some serious exploration as a potential vehicle for achieving this goal.

CHAPTER SIX

MORE CURRICULAR ALTERNATIVES FOR ART

Multifaceted/Cognitive Development Approaches

No comprehensive examination of successful approaches to designing curriculum in art would be complete without an in-depth discussion of those approaches specifically designed to foster critical or higher order thinking skills in children. These approaches, often thought of as multifaceted or multidisciplinary, typically discuss school art programs in terms of visual literacy and/or visual problem finding and visual problem solving. Teaching for the acquisition of enhanced visual perceptual skills and the creative application of these skills is critical to the success of these programs. Some programs created under this approach even go so far as to substitute the word "problem" for the more traditionally used term "project" in an attempt to send the message to students, teachers, administrators, and parents alike that children must think, not recreate, in order to make and study art. Often visual concepts that need to be learned in art are identified and sequenced in cognitive development programs.

The past 10 years have seen a significant shift in art curricula toward what many call a discipline-based or concept-centered approach to teaching art. Early on, discipline-based art education (DBAE) approaches clearly fit into a curricular category discussed a bit later in this chapter called Academic Rationalism. Recently, however, DBAE has become "dbae," and the approach has broadened and evolved so that the content of these programs can no longer be seen as necessarily pro-male, pro-Western, elitist, or exclusionary. Although this multifaceted approach continues to draw from the disciplines of art production, art history, art criticism, and aesthetics, each of these disciplines are now defined in the broadest possible terms. By virtue of their increased content, discipline-based approaches provide art teachers with vehicles for exploring a wide variety of aesthetic and cultural issues and problems.

Interestingly enough, the generic forms of discipline-based art education being implemented today are being created by art teachers for art teachers. These curric-

ula typically still feature an emphasis on art production, but they are also concerned with using the disciplines of art to address visual, anthropological, cultural, historical, and social questions that cross gender, ethnic, and cultural boundaries. (For a useful example of discipline-based art education as a theoretical approach that can be adapted to a variety of teaching situations see *Discipline-based Art Education: A Curriculum Sampler* edited by Kay Alexander and Michael Day available from the Getty Center for Education in the Arts.)

Academic Rationalism

Approaches which seek to maximize the educational experience by sifting through humankind's most significant accomplishments and distilling them into curricular content fall into the general category of Academic Rationalism. After all, the rationale goes, children spend more time in front of TV than they do in school so why waste valuable time on anything that is not a quintessential example of the good, the true, and the beautiful.

This approach has largely fallen out of vogue in recent years, but I must confess that I experienced it when I went to a Catholic boys high school in the early 1960s. The program of study called the "Classical Honors Program" was designed to expose us, as its name implies, to the classics, the masterpieces, the greatest accomplishments of Western man. (Remember it was the 1960s and an all-male school.) In a way, this and similar programs remind me of those late-night television commercials that offer the 100 greatest books ever written or two compact disks of the world's greatest classical masterpieces. When it comes to art, this approach also seeks to limit instruction to acknowledged masterpieces, and continuing the analogy, if those classics programs could be called "the great books," an art program like this could be tabbed "the great looks."

Many could argue that DBAE fell into this category when first posited as a vehicle for expanding the content of public school art programs. It, too, attempted to identify the good, the true, and the beautiful. It, too, attempted to maximize the impact of art education by seeking to include only the strongest, most compelling visual examples in its content base. But early in its evolution, and to its credit, the difficulties encountered in choosing what to include and what to exclude were realized, and this ultimately brought DBAE to a new level of openness.

The Curriculum as Technology

I began my teaching career during the late 1960s and spent the next 8 years teaching art and photography in two high schools in suburban Chicago. This period marked the last time of educational reform previous to the current one. Among other things, this was the era of the *behavioral objective.* As is typical of periods of reform in education, the public at large was interested in holding educators accountable for the amount of learning going on or not going on in schools. As a result, educators became even more interested than usual in quantifying learning. At that time it was thought that student achievement could be more accurately measured if the educational goal were broken down into a

series of small, clearly observable steps that could be measured against a pre-determined criterion. Teachers and curriculum developers alike spent massive amounts of time constructing lists of behavioral objectives that usually read something like "The learner will be able to tie her shoes correctly in eight out of ten attempts." Students who were only able to tie their shoes correctly seven out of ten times did not meet the criterion and went back for remediation.

Over-reliance on behavioral objectives sometimes trivialized the learning going on in schools because there seemed to be no place for learning that was hard to observe or unanticipated at the outset of the learning experience. Over time, the strict reliance of the curriculum-as-technology approach on behavioral objectives softened so that a broader view of quantifying learning could be accommodated. The term Expressive Objective (Stake, 1975) was coined to cover learning that was of value but not anticipated at the lesson's outset. Currently, performance assessments of student learning are in demand and, therefore, many curricula include performance objectives as a means for measuring student accomplishment.

The Amalgamated Curriculum

The philosophical approach to curriculum construction currently most prevalent in all subject areas including art seems to be the *amalgamated curriculum.* This approach in its attempt to address the concerns, needs, and standards of all educational consumers, mirrors the goals of the American educational system which attempts to educate all children according to their individual abilities and proclivities. Instead of limiting or focusing its parameters on a distinct philosophical orientation, this approach seeks to pick the most desirable qualities of each of the other curricular approaches and meld them into an effective conglomeration of educational content and practice. As noted in Chapter 1, this approach seems to be prevalent because it contains something for everyone. By being at least partially inclusive of all curricular philosophies, the amalgamated curriculum effectively avoids the potential for dissatisfying some educational partners that one of the more focused approaches (discussed earlier) might encounter. What this approach loses in terms of concentration, it gains in general acceptability and lack of controversy.

Because this approach can contain major portions of each of the other strategies mentioned, it will be discussed and illustrated in greater detail in the rest of this book. As the individual reader, you may need to keep in mind your own school district and student populations and refer back to or import some data from one of the more focused approaches to fit your situation. You will need to unite the necessary components of an art curriculum with the philosophical orientation your school district or individual school has chosen to follow. Then you can begin to move from theory toward practice. Notice the operative word in the previous sentence is "begin." For one may not move directly from theory to practice. The intervening step, the "translation" if you will, is what ultimately becomes known as the curriculum. A more concrete example of what such a curriculum might look like will be provided in the next chapter.

Art is a nation's most precious heritage.
For it is in our works of art that we reveal
to ourselves, and to others, the inner vision
which guides us as a Nation. And where there is
no vision, the people perish.

— Lyndon B. Johnson

SECTION THREE

SOME EXAMPLES FOR CONSIDERATION

The final three chapters of this book are devoted to translating theory into practice in art education. Art teachers are almost by nature pragmatists: They are concerned with what works in their classrooms. They also well know that what looks good on paper (in theory) often needs to be revised during implementation to make it relevant for their students. As such, these art teachers, these pragmatic practitioners are also front-line researchers. They conduct the kind of basic educational research that theorists need to have access to on a continuing basis.

One purpose of this final section is simply to acknowledge the value of this contribution by art teachers to the theoretical foundations of art education. A second purpose is to encourage art teachers to maximize the benefits that can be garnered by their unparalleled knowledge of what works by actively engaging in the process of creating a well documented, well articulated art curriculum for their schools and school districts. This final section is, in fact, a charge to all art teachers to use their creative and communicative skills to forge curricula that are educationally relevant and tailored to meet the needs of their students and the society these students will be members and indeed leaders of as adults.

Chapter 7 provides a curriculum framework based on the amalgamated-curriculum model. Chapter 8 describes the process involved in creating the art curriculum at the district level, and Chapter 9 deals with perhaps the most critical curricular topic of all, assessment and evaluation.

"Logic is the beginning of wisdom, not the end."
— Mr. Spock, *Star Trek VI*

CHAPTER SEVEN

TRANSLATING THEORY INTO PRACTICE

The Amalgamated Curriculum Approach: An Example

Chapter 2 listed and defined the elements or basic components of an art curriculum. They included

1. Identifying what children should learn—the goals of the curriculum.

2. Selecting and classifying appropriate concepts, subjects, themes, and other related sources for programmatic content.

3. Incorporating suitable instructional technologies that allow the body of knowledge to be effectively and efficiently transmitted to students who may possess a variety of learning styles and proclivities.

4. Accounting for diversity in cultural, social, and ethnic backgrounds and for gender differences.

5. Devising valid and appropriate ways to evaluate the outcomes of the educational process.

Three ancillary, but still vital, features of a well crafted curriculum were discussed:

• **Scope**, the extent and depth to which content is covered.

• **Sequence,** an order in which educational experiences are presented that seeks to build new knowledge based on previous experience.

• **Articulation,** the dissemination of curricular information across the school and across the school district so that all partners in the educational process are informed concerning the goals, objectives, themes, and projected outcomes of the art program.

Following is one example of an amalgamated program containing these components. It is clearly not the only example of a successful art program that could be cited. However, because it contains aspects of all the other philosophical approaches to constructing curriculum explored thus far, it is hoped that you, the art specialist, can adapt it to fit the needs of your students and your teaching situation. It should be of value even to those whose school districts have chosen a specific philosophical orientation to follow.

The amalgamated-curriculum model presented here is divided into five categories:

1. A **Curricular Flowchart** which lists concepts, constructs, disciplines of art, principles, and terms that children will be expected to learn through their experiences in art.

2. A **Yearly Curriculum Overview** chart which allows the district's art teachers to focus on the goals, objectives, and the like of each year in the school art program.

3. A sample **Unit Plan** which breaks the yearly overview into units of study.

4. A **Lesson Planning Format** which can be used to create a series of related lessons that seek to accomplish the goals listed in the unit plan.

5. A **Glossary of Art Terms** which functions as a way of unifying the art teachers' understanding of each of the visual concepts they have chosen to include in the district's art curriculum.

A Curricular Flowchart for Art

Table 2 contains a sequence of items for an art curriculum. The sequence was informed and determined by incorporating and synthesizing a wide variety of notions. Information was gleaned from such diverse areas as research on child development and creativity, Bloom's Taxonomy, Gardner's theory of multiple intelligences, and the South Carolina Basic Skills Assessment Program. To aid in sequencing the items, a thorough analysis was conducted of concepts, constructs, and themes contained in classroom texts for all grade levels of reading, math, and social studies. Finally much attention was paid to the inclusion of what have been called traditional and frontier concepts (Diblasio, 1985) from the disciplines of art.

In addition, over 100 art teachers from six school districts in South Carolina wrestled with a much larger pool of potential items with each district team arriving at similar but different ideas of what needed to be included and when it needed to be taught.

Therefore, I cannot emphasize enough that you, the reader, should realize *the items and sequence suggested by this framework need to be adapted to fit your teaching situation.* For this chart to have any value, it must be specifically

tailored to fit the needs of your school district's students. This flowchart is presented merely to give you a place to begin the curriculum development process, not a place to end it.

To those who find the chart unrealistic or overly ambitious, remember it is a starting point so why not start with a model that offers the highest aspirations for school art programs? In order to assist you in adapting this flowchart and all the other formats presented in this chapter, unsequenced (blank) copies are provided in Appendix A.

TABLE 2
CONCEPTS, CONSTRUCTS, DISCIPLINES, PRINCIPLES, AND TERMS:
A CURRICULAR FLOWCHART FOR ART

Grade:	K	1	2	3	4	5	6	7	8	9	10	11	12
Disciplines of Art													
Art Production	•	•	•	•	•	•	•	•	•	•	•	•	•
Aesthetics		•	•	•	•	•	•	•	•	•	•	•	•
Art Criticism		•	•	•	•	•	•	•	•	•	•	•	•
Art History			•	•	•	•	•	•	•	•	•	•	•
Metacognitive Skills													
Comprehend	•	•	•	•	•	•	•	•	•	•	•	•	•
Visualize	•	•	•	•	•	•	•	•	•	•	•	•	•
Summarize		•	•	•	•	•	•	•	•	•	•	•	•
Predict		•	•	•	•	•	•	•	•	•	•	•	•
Self-Question			•	•	•	•	•	•	•	•	•	•	•
Cognitive Skills													
Compare	•	•	•	•	•	•	•	•	•	•	•	•	•
Recall	•	•	•	•	•	•	•	•	•	•	•	•	•
Analyze		•	•	•	•	•	•	•	•	•	•	•	•
Evaluate		•	•	•	•	•	•	•	•	•	•	•	•
Interpret		•	•	•	•	•	•	•	•	•	•	•	•
Infer			•	•	•	•	•	•	•	•	•	•	•
Synthesize			•	•	•	•	•	•	•	•	•	•	•
Principles of Creativity													
Curiosity	•	•	•	•	•	•	•	•	•	•	•	•	•
Experimentation	•	•	•	•	•	•	•	•	•	•	•	•	•
Imagination	•	•	•	•	•	•	•	•	•	•	•	•	•
Originality	•	•	•	•	•	•	•	•	•	•	•	•	•
Flexibility		•	•	•	•	•	•	•	•	•	•	•	•
Fluency		•	•	•	•	•	•	•	•	•	•	•	•
Invention				•	•	•	•	•	•	•	•	•	•

Grade:	K	1	2	3	4	5	6	7	8	9	10	11	12
Elaboration					•	•	•	•	•	•	•	•	•
Intuition					•	•	•	•	•	•	•	•	•
Principles of Design													
Repetition		•	•	•	•	•	•	•	•	•	•	•	•
Rhythm		•	•	•	•	•	•	•	•	•	•	•	•
Variation		•	•	•	•	•	•	•	•	•	•	•	•
Balance		•	•	•	•	•	•	•	•	•	•	•	•
Contrast		•	•	•	•	•	•	•	•	•	•	•	•
Dominance/Emphasis			•	•	•	•	•	•	•	•	•	•	•
Unity			•	•	•	•	•	•	•	•	•	•	•
Elements of Design													
Line	•	•	•	•	•	•	•	•	•	•	•	•	•
Shape	•	•	•	•	•	•	•	•	•	•	•	•	•
Space	•	•	•	•	•	•	•	•	•	•	•	•	•
Form	•	•	•	•	•	•	•	•	•	•	•	•	•
Texture	•	•	•	•	•	•	•	•	•	•	•	•	•
Depth			•	•	•	•	•	•	•	•	•	•	•
Value				•	•	•	•	•	•	•	•	•	•
Color Theory													
Color/hue	•	•	•	•	•	•	•	•	•	•	•	•	•
Primary		•	•	•	•	•	•	•	•	•	•	•	•
Warm/Cool			•	•	•	•	•	•	•	•	•	•	•
Secondary			•	•	•	•	•	•	•	•	•	•	•
Tertiary/Intermediary				•	•	•	•	•	•	•	•	•	•
Complimentary				•	•	•	•	•	•	•	•	•	•
Neutral				•	•	•	•	•	•	•	•	•	•
Intensity					•	•	•	•	•	•	•	•	•
Monochromatic					•	•	•	•	•	•	•	•	•
Tint/Shade					•	•	•	•	•	•	•	•	•
Local Color									•	•	•	•	•
Triadic color									•	•	•	•	•
Simultaneous Contrast									•	•	•	•	•
Visual Concepts & Related Constructs													
Art	•	•	•	•	•	•	•	•	•	•	•	•	•
Artist	•	•	•	•	•	•	•	•	•	•	•	•	•
Description	•	•	•	•	•	•	•	•	•	•	•	•	•
Observation	•	•	•	•	•	•	•	•	•	•	•	•	•
Original	•	•	•	•	•	•	•	•	•	•	•	•	•
Ranking/Sorting	•	•	•	•	•	•	•	•	•	•	•	•	•
Relationships	•	•	•	•	•	•	•	•	•	•	•	•	•
Technique	•	•	•	•	•	•	•	•	•	•	•	•	•
Aesthetician		•	•	•	•	•	•	•	•	•	•	•	•
Architect				•	•	•	•	•	•	•	•	•	•

Grade:	K	1	2	3	4	5	6	7	8	9	10	11	12
Architecture		•	•	•	•	•	•	•	•	•	•	•	•
Art Critic		•	•	•	•	•	•	•	•	•	•	•	•
Art & Nature		•	•	•	•	•	•	•	•	•	•	•	•
Art & Technology		•	•	•	•	•	•	•	•	•	•	•	•
Beauty		•	•	•	•	•	•	•	•	•	•	•	•
Craftspersonship		•	•	•	•	•	•	•	•	•	•	•	•
Design/Composition		•	•	•	•	•	•	•	•	•	•	•	•
motion/mood		•	•	•	•	•	•	•	•	•	•	•	•
Geometric		•	•	•	•	•	•	•	•	•	•	•	•
Horizon/Ground line		•	•	•	•	•	•	•	•	•	•	•	•
Organic/Inorganic		•	•	•	•	•	•	•	•	•	•	•	•
Overlap		•	•	•	•	•	•	•	•	•	•	•	•
Pattern		•	•	•	•	•	•	•	•	•	•	•	•
Self-image		•	•	•	•	•	•	•	•	•	•	•	•
Sequence		•	•	•	•	•	•	•	•	•	•	•	•
Size		•	•	•	•	•	•	•	•	•	•	•	•
Art Historian			•	•	•	•	•	•	•	•	•	•	•
Assemblage			•	•	•	•	•	•	•	•	•	•	•
Collage			•	•	•	•	•	•	•	•	•	•	•
Craft			•	•	•	•	•	•	•	•	•	•	•
Decoration			•	•	•	•	•	•	•	•	•	•	•
Style/Period of Art			•	•	•	•	•	•	•	•	•	•	•
Symmetry/Asymmetry			•	•	•	•	•	•	•	•	•	•	•
Visual Weight			•	•	•	•	•	•	•	•	•	•	•
Abstract				•	•	•	•	•	•	•	•	•	•
Construction				•	•	•	•	•	•	•	•	•	•
Deconstruction				•	•	•	•	•	•	•	•	•	•
Distortion				•	•	•	•	•	•	•	•	•	•
Fore/background				•	•	•	•	•	•	•	•	•	•
Non-objective				•	•	•	•	•	•	•	•	•	•
Proportion				•	•	•	•	•	•	•	•	•	•
Non-representational				•	•	•	•	•	•	•	•	•	•
Representational				•	•	•	•	•	•	•	•	•	•
Art Vocations						•	•	•	•	•	•	•	•
Highlight						•	•	•	•	•	•	•	•
Perspective						•	•	•	•	•	•	•	•
Rendering					•	•	•	•	•	•	•	•	•
Shadow					•	•	•	•	•	•	•	•	•
2D/3D						•	•	•	•	•	•	•	•
Aerial Perspective						•	•	•	•	•	•	•	•
Kinetic						•	•	•	•	•	•	•	•
Animation							•	•	•	•	•	•	•
Armature							•	•	•	•	•	•	•

Grade:	K	1	2	3	4	5	6	7	8	9	10	11	12
Figure/Ground							•	•	•	•	•	•	•
Motif							•	•	•	•	•	•	•
Positive/Negative							•	•	•	•	•	•	•
Academic relevance							•	•	•	•	•	•	•
Atmospheric perspective							•	•	•	•	•	•	•
Chiaroscuro							•	•	•	•	•	•	•
Composite							•	•	•	•	•	•	•
Detail							•	•	•	•	•	•	•
Fragmentation							•	•	•	•	•	•	•
Perception							•	•	•	•	•	•	•
Scale							•	•	•	•	•	•	•
Symbolism							•	•	•	•	•	•	•
Architectural Facade								•	•	•	•	•	•
Linear Perspective								•	•	•	•	•	•
Transformation								•	•	•	•	•	•
Typography								•	•	•	•	•	•
Graphic Design									•	•	•	•	•
Patronage									•	•	•	•	•
Propaganda									•	•	•	•	•
Visual Communication										•	•	•	•
Subject Matter/Themes													
Fantasy			•	•	•	•	•	•	•	•	•	•	•
Realism			•	•	•	•	•	•	•	•	•	•	•
Multiculturalism			•	•	•	•	•	•	•	•	•	•	•
Portraiture				•	•	•	•	•	•	•	•	•	•
Caricature				•	•	•	•	•	•	•	•	•	•
Land/city/seascape				•	•	•	•	•	•	•	•	•	•
Still Life					•	•	•	•	•	•	•	•	•
Genre							•	•	•	•	•	•	•
Religion							•	•	•	•	•	•	•

The Curriculum Overview: A Year at a Glance

Once the art teachers in a school district have chosen and ordered the con-
cepts, constructs, disciplines, principles, and terms they wish to include in the
school art program, it becomes possible to break this general list into yearly
segments. But the list contained in Table 2 makes up only a fraction of the art
curriculum. Many other important issues have yet to be decided. What are the
specific goals for the art program in each year of school? Exactly what should
the students know and be able to do when they finish the first grade? What
themes will be explored and when will they be introduced? Which *Western and
non-Western cultures, artistic styles, periods, and even specific artists* will be
investigated by each grade level or high school art class? Where can the art
program begin to naturally integrate its content with the content of other subject
areas? How will *gender equity* be ensured in the curriculum? Which *media* will
be included for each child to interact with in any given school year? When each
of these issues is resolved, it becomes possible to choose or design appropri-
ate methods for conducting student *assessments of learning.* How will student
performance—whether it be art production, written journals, self-critiques,
group critiques, class participation, or effort—be evaluated?

Finally, how will this district curriculum interface with any state curriculum
frameworks in force? These critical aspects of the school art program must be
melded into the written curriculum in order for the curriculum to even begin to
maximize its potential impact on the quality of the art program and the way it is
viewed by other members of the educational establishment.

Table 3 shows what such a yearly overview might look like. You may recog-
nize some terms that come from your state art framework or the Basic Art Skills
poster that was published several years ago by the National Art Education
Association (NAEA). One category, Art doctrine, was borrowed from the late
Jim Cromer in his book from this NAEA "Point of View" series entitled The
History, Theory, and Practice of Art Criticism in Art Education (1990). In this
case, art doctrine refers to developing a personal philosophy of art. In essence,
this term could be thought of as a synonym for aesthetics. It was added to the
four categories already a part of so many state art frameworks because neither
aesthetic perception nor aesthetic valuing has any direct connection to devel-
oping a personal philosophy of art. Aesthetic perception refers to developing
the ability to perceive visual and tactile qualities in works of art and aesthetic
valuing is described in terms that generally place it in the category of art criti-
cism.

The Unit Plan

One of the most critical points in the curriculum development process involves
unifying or sequencing day-to-day (or in the case of elementary art, week-to-

Table 3
School Arts Program Curriculum Overview
Grade Level:_____

Goals:	Themes:	Concepts:	Aesthetic Perception:	Creative Expression: Media & Techniques (AS)	Cultural Heritage: Periods, Styles, Artists (AH)	Aesthetic Valuing: (AC)	Art Doctrine Philosophy of Art (AES)	Evaluation & Assessment

week) educational experiences so that they flow naturally, building new learning upon previous experiences. Achieving this goal is the role of the unit plan.

The unit plan breaks the school year down into areas of study. Traditionally, teaching units (a unit being a series of related lessons) have been created around the media intended to be incorporated into the art program. This should not be surprising because, as often stated, teachers tend to teach the way they themselves have been taught. When most of us look back to our college courses and beyond, that is exactly what we experienced. Courses were organized around media: drawing, painting, ceramics, printmaking, photography, sculpture, and crafts. Plus, from a practical perspective, it makes perfect sense to look at which materials are available in cabinets or storage areas and begin from there.

However, the amalgamated approach with its sequential list and yearly overviews offers several equally practical and educationally exciting approaches to designing learning experiences for students. Now the school year can be divided into units of instruction that revolve around cognitive development, themes, cultures, historical periods, geographic locations, and gender and social issues. Media and techniques can be chosen for their appropriateness and efficiency within this larger context.

Table 4, a sample unit plan, shows how such a unit could be structured.

Lesson Plans

Lesson plans are the "bread-and-butter" curriculum planning instruments for all teachers. They provide the structure needed to conduct classes on a daily basis. Lesson plans give direction and organization and help present information in powerful, effective, and efficient ways. Often lesson plans have little or nothing to do with the planning books many are required to hand in weekly to principals. The comments contained in those books function more like appointments then lesson outlines.

Given the large number of preparations art specialists have to make each week the lesson plan should be simple yet informative. It should be easy to construct but detailed enough for a substitute art teacher to use should the need arise. Also lesson plans often take more than one class period to complete. This last fact should be kept in mind when inspecting Table 5 (see page 54), a sample format for planning daily or even weekly lessons.

A Glossary of Terms

It would constitute cruel and unusual punishment for me to take you this far without providing you with a glossary that begins to define the items that make up the massive list of concepts, constructs, disciplines, principles, and terms presented earlier in this chapter. Because articulating the curriculum to all members of the educational partnership is critical to the way any curriculum

	Table 4 Unit Plan			
	Concepts Objectives	Instruction Motivation	Student Activities	Evaluation
Aesthetic Perception				
Creative Expression (AP)				
Cultural Heritage (AH)				
Aesthetic Valuing (AC)				
Art Doctrine (AES)				

Table 5
Lesson Plan

| Teacher: | Grade: | Time Allowed: |

Problem Title & Thematic Description:

Create a short name that encapsulates the problem being explored and list the aesthetic and/or cultural themes that will be covered in this lesson.

Art Concepts/Content:

List concepts taken from the sequentially organized list created and agreed upon by each school district. Two or three concepts are appropriate per lesson.

Instructional Objectives: (The child will be able to...)

Use action words like identify, construct, draw, assemble, report, recite, analyze, compare, contrast, design, build, sketch, or initiate. An objective should be written for each concept included in the lesson.

Instruction/Motivation/Resources/Vocabulary:

The "delicious idea" (problem) and suitable examples from the real world of art that stimulate the child to want to perform. Instruction should motivate and facilitate as it provides opportunities for the teacher to include relevant information from the disciplines of art.

Production:

(Note - Activities and assignments in any of the other disciplines of art can be added to or substituted for art production.)

Evaluation: Measuring student learning (i.e., self-assessment, individual critiques, class critiques, anecdotal records, journals, sketch books, check sheets, examinations, class participation, and effort).

In the case of student work, does the art product solve the assigned problem? To what degree has the student remained within the parameters of the assignment? If students have gone beyond the assigned parameters, have they merely failed to consider all of the components of the assignment or have they discovered and accumulated unforeseen learning that is of value?

Materials: (Media)

A list of all the materials necessary for the students to solve the assigned visual problem.

Lesson Assessment: (How can this lesson be improved?)

functions, it is important that everyone has a thorough understanding of what the curriculum is trying to accomplish. This common or global understanding must extend from the loftiest goals set for art programs to the most elementary definition of terms like "line" and "shape."

The glossary (see Appendix B) attempts to provide a starting point for creating that understanding. The definitions were again constructed and written by art specialists working in teams. They have been refined several times but language in art is constantly changing and often more than one way exists for conveying similar if not identical concepts. Therefore, you should anticipate the need to refine this glossary so that it too suits your needs.

Summary

In many ways this chapter may be the most important one in this book. It was intended to accomplish two crucial things: First, to challenge art teachers to look to the future and institute significant, far reaching, and educationally high-minded change and, second, to provide a malleable, adaptable example of a district art curriculum model suitable for attempting to institute such change.

I am fully aware that this model is not the one single correct way to teach art. It is presented to make you think about the issues confronting the profession and society as a whole. In its defense, consider for a moment the following scenario:

A group of teachers appears before a typical local board of education and demonstrates their design of a gender-neutral curriculum that would provide students from a wide variety of ethnic and social backgrounds with opportunities to improve their abilities to *comprehend* new material; *visualize* answers to problems; *imagine* what could be; *analyze* and *summarize* information; *predict* outcomes from available data; *make informed evaluations* of their work and the work of others; *compare, contrast, and analyze* images and objects; *be curious* about life; *be cognitive risk takers* unafraid to *experiment*; develop the cognitive *fluency* to generate numbers of ideas and potential answers for problems; exhibit *flexibility* in being able to give up one idea for a better one; *recognize and appreciate originality* and uniqueness; and *elaborate* simple ideas and make them better. This program of study accomplishes this extension of student abilities by utilizing images and writings from past and contemporary cultures made by men and women from here and all around the world.

The list of student abilities could go on but I'm sure you get my point. Any program of study that could document such accomplishments would receive the unconditional support of almost any board of education. Imagine this fictitious board's reaction when this group of teachers reveals that they are the district's art teachers. A fantasy you say—of course, but you and I both know that that list is just a sample of the metacognitve, cognitive, creative, and cultural skills that art teachers communicate to students on a regular basis.

"I am certain that after the dust of centuries has passed over our cities, we too will be remembered not for our victories or defeats in battle or politics, but for our contribution to the human spirit..."

- John F. Kennedy

CHAPTER 8

TEACHERS WRITING FOR TEACHERS

Leadership and the Art Specialist

Once the "intellectual buy-in" necessary to seek curricular change has occurred, the task at hand becomes one of creating and then actualizing the curriculum. This marks a crucial moment in reforming art programs, one that may indeed make the task seem too mammoth to even contemplate let alone accomplish. However, this moment also marks a cusp in which one individual, one dedicated art teacher, can make a tremendous difference. This is the hour when leadership and dedication among art specialists can be the decisive components for ensuring success.

In a perfect world each school district would have selected such a leader and appointed that person to the position of district art supervisor or art consultant. However, this is not a perfect world, and most school districts in this country have not reserved a place in their organizational structure for such an administrator.

But leadership can, and indeed must, come from teachers when it is not forthcoming from administrators. One dedicated individual can *work within the system* to spearhead the effort and serve as a model for curricular reform in art education. One individual can inspire fellow art teachers to band together and commit time, effort, and serious thought to organize and articulate their rationales, goals, and objectives for the betterment of the art program.

Obviously, this is no small job and cannot be accomplished during one's spare time or planning period—nor should it. Support from the school district for curriculum reform must also be forthcoming. (Before you reject the prospect for school district support for art education reform out of hand, remember that, even though the global economy is still uncertain, educational reform continues to move ahead during the 1990s). In many states, special funding has been allocated to support curriculum reform in all subject disciplines. This support

can take many forms and be used in various ways. It may come from the state department of education in the form of district grants for curriculum development or from an internal reallocation of funds by individual school districts. But it is necessary to *actively seek* the financial support needed to effect reform *because it will almost never be offered* .

Getting Organized: Funding and Other Steps

To make grant proposals or requests for support that much more powerful, gather background evidence that supports your proposal. Conduct a review of past reports filed by school district accreditation teams. Look for comments and suggestions that specifically refer to strengthening art programs. Also, spend a little time researching the goals of your school district. These are usually on file at the district office or may even be in the school library. Highlight those goals that refer directly to or even tangentially relate to art as reasons for promoting, strengthening, or redesigning the art curriculum. If such goals are missing, suggest new policies for adoption by the district board of education. Finally, do not overlook the vast amount of supportive information published through state and national art education associations, the PTA, and the National School Boards Association that provide evidence and support for art education.

A good bit of the first chapter in this book was dedicated to an exploration of the often less-than-ideal conditions that art teachers currently endure in public schools. These conditions can be summed up in one word—isolation. So the first step in reforming the curriculum involves breaking through these various forms of isolation. Art specialists must communicate and work with each other on a regular basis. This can be accomplished in several ways. *Monthly after-school meetings* can be hosted at schools around the district. If the district has not appointed an art consultant at the district level, the art specialists can seek permission to *elect an art supervisor* of their own. While this may begin as an unpaid extra duty, many are elevated to a district-supported position because of the improved functioning of the art program. Also, communication by memo through district mail service may not be instantaneous but can serve to keep everyone "in the loop" as developments occur.

Find out who in your school district is responsible for scheduling *teacher in-service meetings.* Make a formal request that some, if not all, of these in-service days be structured so that the district's art teachers can meet together and concentrate on curriculum design. Offer to help plan such meetings. When planning for these meetings, seek district support to *bring in outside resources that have expertise in curriculum construction in art* to educate and inspire your art teachers about the potential benefits of curriculum reform. University art educators and other art discipline experts (i.e., studio artists, art historians, art critics, and aestheticians) are often willing to share their knowledge with public school art teachers. If you find a consultant that seems to have an orientation to creating an art curriculum convergent with your district's approach to education, then in-service days could be expanded to work with this individual to

include *university curriculum development courses for credit and/or teacher recertification points sponsored by the school district.*

Developing the Curriculum: A Process Model

The most critical and productive step that must be taken in the curriculum development process is to divide the labor so that the job at hand becomes manageable. This is often accomplished by the creation of a *district-wide art curriculum writing team (CWT).* This committee should be inclusive rather than exclusive. Offer membership on this team to any art specialist and district curriculum specialist willing to serve. Generally speaking, those art teachers not committed to change will not ask to serve on such a team so chances are high that those who do volunteer will be like-minded enough to be able to work together. Including one or more district curriculum specialists on the CWT opens up one more line of communication between art and the school administration, adds another level of expertise to the discussions, and provides art teachers with an opportunity to educate an administrator(s) about the importance of art education.

If the CWT is fortunate enough to receive some financial support from the school district or other source, there are several ways in which this support can be used to inspire, instill, and institutionalize curriculum reform. For example, the support could be used to fund summer activities—background research (always a good idea), the actual writing of the curriculum, or attendance by one or more members of the CWT at a summer institute on leadership and/or in curriculum construction. Regional summer curriculum institutes are a great way to bring back new strategies to the school district.

Some summer assigned time could also be used to conduct a content analysis of the textbook series used in your school district. This review should extend beyond art textbooks to include an analysis of the themes and concepts introduced in social studies, language arts, geography, math, and science. Knowing when concepts, themes, and cultures are being introduced in other subject areas can be crucial to sequencing the concepts, themes, and cultures introduced in art.

In seeking to create an art curriculum for your school district do not overlook the work that may have already been done by neighboring school districts. Try to obtain copies of any district-made art curricula in your area or state. CWT members can critique these documents so that your art curriculum avoids any problems identified in those of your neighbors.

If other school districts in your region are also struggling with art curriculum reform, a partnership can be forged in which two or more school districts share the expenses of creating a written curriculum that can be shared with minor adaptations. Even if each district in this partnership maintains separate CWTs, the districts could still share expenses for outside consultants, courses for

recertification credit, or even on-site courses/workshops that provide graduate credit for art teachers who wish to work toward advanced degrees.

Choosing a Format for the District's Art Curriculum

The curriculum document can, of course, take many forms. The two most common ones for district-written art curricula are "frameworks" and "cookbooks." Frameworks provide structure and sequence by listing goals, concepts, themes, cultures, artworks, and media required for each grade level. They also often make concrete suggestions about assessing student learning and provide selected examples in the form of sample units and lessons to guide teachers in following the planning format adopted by the CWT. They actually use these examples to train teachers in how to use the document's planning formats to organize and inform their planning.

Frameworks leave room for teachers to flesh out the details of units and lessons. They are structured in that they list parameters for teachers but open ended because they allow teachers great latitude to draw connections between and among the required concepts, themes, cultures, and media that fall within the parameters articulated for a given school year. Frameworks assume that teachers must teach from their individual strengths in order to tailor their programs to meet the needs of their students and that they have the expertise necessary to create units and lessons that will allow students to achieve the goals established for each grade level.

Curriculum cookbooks, by their very nature, are much more specific than curriculum frameworks. They often consist of a collection of detailed lesson plans that seek to provide curricular guidance by listing example after example of what should be done in art by teachers and students. Curriculum cookbooks are sometimes seen as overly prescriptive, especially by teachers who may not have had an opportunity to contribute their favorite "recipes" for art when the cookbook was being assembled. In their purest, most delineated form, they may in effect be well intentioned attempts to "teacher proof" the curriculum by greatly reducing the teacher's role in the creative planning process. Curriculum cookbooks are much easier to create than frameworks because they function as an anthology of good lessons. They can be authored by many teachers without paying a great deal of attention to the overarching issues that face curriculum developers in art education. On the other hand, cookbooks are also easily ignored by art teachers who refuse to give up the creative input and control they enjoy by doing their own planning.

Regardless of which of these forms a district art curriculum takes, one must not lose sight of the fact that as soon as the curriculum is printed, bound, and distributed to the district's art teachers it begins to lose its currency and viability. The curriculum is never "written in stone." It should never, in fact, be consid-

ered to be completed. It must evolve and grow to meet the ever changing needs of the students.

Pacing Curriculum Reform

Once the decision has been made to undertake reforming an existing art curriculum or creating one where none exists, the urge to finish the project expeditiously must be tempered by a realistic understanding or estimate of how long the process takes. The creation of a flowchart that breaks the process down into manageable, attainable components can do much to reduce anxiety over the size of the undertaking and to set the stage for a division of labor among the CWT members.

My experience over the past several years with several school districts in South Carolina is that it takes 2 to 3 years for the curriculum revision process to be completed. This estimate includes 6 to 12 months for field-testing the new or revised curriculum and making adjustments to it based on the feedback received from the field-testers.

Field-testing provides one more opportunity for the district's art teachers to make the curriculum more relevant to their students and develops even higher levels of "ownership" in the curriculum itself. Field-testers can be members of the CWT, but care should be taken to allow those who have not had a hand in developing the document to have ample opportunity to critique it. While some of these comments may fall into the "sour grapes" category, the ultimate outcome will be a document that is familiar and acceptable to the vast majority of the district's art teachers.

Above all, the curriculum reform process requires organization from beginning to end. The steps to instituting curriculum reform as delineated in this chapter include

- Securing state or district support for curriculum reform.
- Forming the curriculum writing team.
- Identifying resources and outside expertise.
- Surveying the existing landscape in terms of reform occurring in neighboring school districts.
- Forming partnerships whenever possible.
- Choosing a format for the document.
- Establishing a pace for the process itself.

As noted at the very beginning of this chapter, the curriculum reform process requires leadership and dedication but those two commodities have never been in short supply in our field—as you well know.

As in other subjects, students should be tested in the arts and their art work evaluated in order to determine what they have learned, and arts education programs should be evaluated to determine their effectiveness.

- Toward Civilization
A Report to the United States Congress on Arts Education
National Endowment for the Arts

CHAPTER 9

STUDENT EVALUATION AND PROGRAM ASSESSMENT

Two of the most problematic areas for art teachers creating a curriculum for their school districts continue to be student evaluation and program assessment. The fact that these two areas are closely related seems to have confounded rather than enlightened attempts to measure or quantify (a) what it is children learn in art and (b) how efficient art programs are at attaining their goals. These attempts are also confounded both by the reality that, for many years, art teachers were discouraged from formally evaluating student work and by the paradox that the kinds of broad-based, anecdotal records long used in art classrooms are now considered to be on the "cutting edge" of educational evaluation.

Evaluating Student Progress

The term *evaluation*, the task of evaluating learning, is usually thought of as summing up learning in the form of grades. This is known as *summative evaluation*. It provides a brief symbolic way of measuring and recording student progress and, in some cases, measuring students against each other.

Summative evaluation has not been a mainstay of public school art programs. Traditionally, most of the evaluation art specialists conduct in their classes has fallen into the category of *formative evaluation* or, more simply stated, teacher observation. Teachers have known since the beginning of formalized schooling in art that the act of teaching also provides evidence concerning student attitudes toward art, student participation in art assignments, problem solving, effort, and behavior. Therefore, art specialists have used formative evaluation techniques to determine if students were assimilating the information being presented and to note effort and progress as students learned in art. Art specialists have also tended to make use of *responsive eval-*

uation techniques to ensure that they were open to learning that was unforeseen but still of value. When students learned things that were unanticipated, good teachers found a way to value that learning while figuring a new way to teach for the learning they originally had in mind (Dunn, 1981). Formative and responsive evaluations provided valid feedback to teachers about student progress in art. These forms of evaluation confirmed the evidence visible in student art works and portfolios, but they did not provide information that would necessarily be considered summative in nature.

Therefore, it became too widely accepted that learning in art was, at best, resistant to accepted forms of academic measurement. This notion has helped to keep art education from achieving a place at the core of general education. Also, the almost impossible logistics of evaluating and documenting learning in each and every art student when one elementary art specialist may see upwards of 700 students per week has contributed to the view of art as an academic lightweight without serious grading policies. Lugging home 700 artworks each week for grading may be unappealing. However, if student learning in art cannot be measured in ways acceptable to educational decision makers, then art programs may continue to be on the fringe of the educational system. The fact that the kinds of measures traditionally valued by the educational establishment have not been particularly responsive to the visual arts does not change the reality that, until very recently, we have had to play by their rules—not ours.

Of course, the rules may finally be changing a bit in art education's favor. The new theoretical work in cognitive science previously discussed and parents' continued interest in schools that prepare children to think and solve complex rather than rudimentary problems has created a situation in which art education can lead rather than follow in creating a new era in educational evaluation. The traditional paper/pencil measures that have driven the educational system for so long have proven to be shallow gauges of learning, and broader, more sensitive appraisals are being demanded and implemented. The most prominent among these new measurement strategies being instituted across the curriculum comes directly from art education—*portfolio assessment*.

Portfolio assessment has long been in use in art education. Student portfolios generally consist of a collection of finished works created in school over a finite period of time. As such, they provide insight into how a student has grown creatively and which media and techniques have been explored in school. But portfolios can include many other items that yield vital pieces of information concerning student learning and development. In addition to finished works of art, portfolios can include such things as:

- Sketches, studies, and preliminary works.
- Samples, that is, a collection of images that have influenced the student artist.
- Reproductions of works by the student's favorite artists.

- Written notes and thoughts concerning the creative process.

- Comments about the problem solving that accompanies going from prelimi- nary ideas to finished product.

In addition, broader conceptions of the types of activities that should be included in quality art programs such as inquiry into the disciplines of cultural heritage (art history), art criticism, and aesthetics have given art specialists more types of learning to measure. Correspondingly, other forms of educational measurement beginning to become more commonplace in art classrooms all across the nation extend and enhance the evidence provided by portfolio assessment. But before you begin getting visions of getting bogged down in labor intensive portfolio reviews and grading hundreds of student term papers, let me reassure you that evaluation can take many non-labor-intensive forms and still be educationally appropriate and valid. Today, many art specialists are using a combination of teacher-directed and student-administered techniques in addition to regular portfolio reviews to evaluate student gains in art.

Following are just a few of the evaluation techniques that art specialists can use to measure student knowledge of art, artists, artistic processes, and art works. Because art teachers frequently teach virtually every student at the ele- mentary and middle school levels, many of these techniques feature a self- administered component in which students rate themselves and/or their peers.

- *Teacher-made check sheets* can be used to allow students to tally whether they have attended to all the criteria included in a visual-problem-solving assignment. Check sheets can be used to actually reinforce the visual con- cepts that the teacher intended the children to learn.

- Students can use *Individual Rating Scales* to evaluate their performance on a given assignment, or small groups can engage in cooperative learn- ing and come up with a consensus evaluation for student art works.

- *Anecdotal Records* such as student journals, sketchbooks or a combination of the two can be kept that seek to highlight student attitudes, preferences, judgments, participation, and even behavior in art. Such journals can be collected periodically, and the teacher can review and make brief com- ments about the work or student statements contained therein.

- *Informal or Process Evaluations* can be conducted in which students are asked to make oral or written statements about their work, fill out reflection sheets structured to encourage them to bring their artistic decision making to a conscious level or provide responses to who, what, when, where, and why questions posed by the teacher as part of a classroom discussion. These evaluations can take place before the culmination of an assignment, and, as such, they form the basis for facilitating growth while the student is actively engaged in the problem-solving process.

- *Formal Critiques* of student work whether done on an individual, small- group, or large-group basis usually occur as a culminating activity.

Beginning students can be asked to classify reproductions of works from the real world of art. More advanced students may be asked to judge works within a cultural context or compare and contrast the aesthetic values of one culture with another as evidenced by art works from each.

- Students can be asked to assume the role a member of any of the art disciplines plays. Such *Role Playing* can provide an opportunity for students to explore the functions and responsibilities of artists, art historians, art critics, aestheticians, or even cultural anthropologists or sociologists. Student-conducted interviews of community members who are engaged in these activities professionally could be tape recorded or videotaped for playback during class time.

- Or students could be assigned the task of conducting *Art Research*. Suggested topics or issues could be provided by the teacher, and students would be required to engage in group brainstorming before engaging in fact finding and data gathering for an article for the school or local newspaper.

This brief listing is intended solely to get you, the reader, thinking about how you can design evaluation instruments that not only measure student growth in art but encourage that growth to continue. Evaluation in the visual arts can be much more than a check mark, sticker, or grade on an art project. It can be even more than taking teacher-made tests, making oral reports, completing written assignments, and writing research papers. When done well, evaluation measures and motivates the learner to continue the quest for more knowledge.

One final note of caution for those curriculum writers who, after reading this section, find themselves highly motivated to strengthen or overstrengthen the evaluative component of their art curriculum. Make sure teachers are only asked to evaluate in appropriate ways and at appropriate times. Avoid creating the notion that your district's art teachers should use all of the previously mentioned techniques in every grade or course they teach. Make evaluation fit their needs and the needs of their students by allowing them to pick appropriate evaluation techniques for their teaching situations.

Assessing the Strengths and Shortfalls of Art Programs

Virtually everything written in this book thus far has as its unstated goal promoting art education to the ranks of other academic disciplines. In short, this book uses curriculum construction in art as a vehicle for attaining educational legitimacy and becoming an equal partner in the educational system. This final section, dealing with program assessment, is certainly no exception to this rule. In fact, while program assessment may be first targeted at making the art program more relevant or responsive to student needs, it certainly has an equal if

not more critical component that looks to assessment as a means to justify the inclusion and expansion of the visual arts in education.

Art program assessment revolves around meeting the goals established for the school district in general and the art program in particular. As such, in its most fundamental form, assessment of the art program begins and ends with art specialists. At the end of each lesson in the planning format provided in Chapter 7, there is a section entitled Lesson Assessment. This portion of the lesson plan is meant to be filled out immediately after the lesson has been taught. It provides art specialists with an opportunity to reflect on the outcomes of the just completed lesson while it is fresh and to make comments concerning how this lesson may need to be revised or extended before it is taught again.

In addition to ongoing assessment of lesson effectiveness, the Questionnaire or Inventory of Personal Interest are two more instruments art specialists can use to measure student attitudes in an attempt to make art programs more timely and personally relevant. If done regularly, basic program assessments like these do much to upgrade the quality of daily lessons and ensure that the art program in a given school remains sensitive to student needs.

But assessing and revising daily or weekly lesson plans on a regular basis and striving for a high degree of personal relevance in art experiences will not alone change the marginal position art occupies in the educational system. Important questions remain such as:

• How can program assessment be used at the school district level to improve the climate for art education?
• How is a program assessment for art conducted?
• Who can and should conduct such an assessment?
• How can the attention, trust, and support of educational decision makers be gained during any period let alone one of significant educational reform?
• What benefits can accrue to the visual arts if a thorough assessment of the program is conducted?

The answers to these questions lie beyond the performance assessment that goes on in individual art classrooms and in several other forms and levels of program assessment that seek to deal with generic or global issues surrounding the position art occupies within the educational system (Dunn, P. C. et al., 1981). Let us examine each question individually.

Q How can program assessment be used at the school district level to improve the climate for art education?

A At the school district level, program assessment should be seen as an opportunity to review the entire art program, gather supportive data, and make recommendations and provide rationales for improving that pro-

gram. Educational decision makers often do not know a great deal about art. Their educational experiences emphasize things like school law and finance rather than 20th century art. But decision makers do want quality schools and can be sensitized to the value of art and to the contributions art can make to the overall school environment. Assessing the art program in ways that make sense to educational decision makers is one way to improve the climate for art education.

One of the most useful forms of program assessment is the *Annual Report of Activities*. Clever art specialists use annual reports as a means to illuminate areas of program accomplishment and examples of school, or district, support. They also use it to highlight program areas that would yield even more educational benefits if they were given more attention and support at the school or district level. By comparing accomplishments with shortfalls and noting the reasons for both, art specialists can usually make a defensible case for expanding the art program.

Another vehicle for documenting current conditions while detailing future aspirations is the *Program Development Checklist*. This is simply one more example of a teacher-developed check sheet. However, instead of listing criteria for students to fulfill, this check sheet is a listing of standards for the school district art program to achieve (Dunn et al., 1981). This checklist functions as a listing of short-, medium-, and long-range goals for the school district's art program and can be completed on a yearly basis to document progress toward achieving or extending the quality of the district art program. It should be revised every 2 or 3 years to reflect new thinking and program aspirations.

The district art curriculum is the first and most logical place to begin the process of creating a program development check sheet because the goals established for the art program, as stated in the district's curriculum, will also provide valuable benchmarks to use to assess program effectiveness. After all, isn't reaching the stated goals of the art program the most critical criterion of program effectiveness? A careful content analysis of the district art curriculum will uncover areas of expertise necessary to teach art effectively as well as types of support required to achieve excellence.

Q How is a program assessment for art conducted?

A The process for conducting an assessment of the overall function and effectiveness of a district art program depends first upon whether the assessment is to be conducted internally by school district personnel or externally by an outside expert, a team of experts, or a regional school accreditation agency.

The vast majority of U.S. school districts show their concern for and commitment to assessing the effectiveness of their programs by setting

aside some time and funding to conduct internal program reviews or internal assessments. This process may be set up on a recurring cycle in which specific areas of the general school curriculum are singled out for attention on a regular basis, for example, once every 5 years.

A team of administrators and faculty are usually charged with conducting this review. Art specialists may find that their field is grouped with several other areas of the general curriculum in this format, but the fact that art is singled out for attention at all is healthy. If the school district has no designated administrator responsible for acting as a liaison between the administration and the art teachers, then art specialists need to become aware of the review cycle and make preparations, and even requests, to serve on this committee.

The assessment process itself should seek to uncover information concerning the current conditions for learning in art. Everything should be listed from the number of art specialists employed per student and their professional qualifications to resources like supplies and equipment and facilities. Even information concerning student and parental attitudes concerning the effectiveness of the art program can be assembled.

Several professional organizations provide valuable guidance for program assessment in art by creating and making available a list of standards for quality school art programs. These standards can be used to measure the current conditions for art learning in a school district against what ought to be. These guidelines can be used to create the questionnaires and checklists included in the information-gathering phase of the internal assessment.

In addition to the foundational things just listed, the success of the art program must be measured against the philosophy and goals of the school district in general and those of the art curriculum in particular. The assessment should pay particular attention to highlighting areas of accomplishment and areas needing attention.

Q Who can and should conduct such an assessment?

 A The previous discussion aimed to make a case for the validity of internal program assessments conducted by a team comprised of art specialists and school administrators. After all, who knows more about the function and effectiveness of school programs than those who teach in them and those who administer them?

However, the recommendations that come from internal assessments can sometimes be seen as self-serving attempts at "empire building." Art specialists do have a vested interest in making recommendations that increase the level of support they receive from the district. Therefore, a system has been created in which schools districts regularly subject

themselves to close scrutiny by a variety of outside agencies to validate or reject the results of internal assessments. These are sometimes referred to as school accreditation visits or *external assessments.*

External assessments also take many forms. As noted, they can refer to assessing the entire school program, as in a visit from a regional school accreditation team, or they can be program specific. School accreditation assessments tend to occur about every 10 years and to focus on academic areas other than art. Even if art was given equal attention during one of these assessments, the length of time between accreditation visits is usually much too long to be of practical use as an art assessment.

Specific program assessments also occur on a regular but shorter cycle or can occur at the request of those involved in the programs. In other words, art specialists can seek outside opinions concerning the quality of their art programs whenever they feel the need to do so. The kind of expertise needed to conduct an external assessment of the art program is readily available. Depending upon need, art specialists can request assistance from professional art education organizations at the local, state, and national levels.

State art consultants, art educators from local universities, or consultants from state arts commissions are usually recognized by school administrators as "outside experts" who possess the necessary background to conduct a review of the art program in a local school district. Plus, these individuals bring a positive bias to the assessment process and are usually anxious that their report serve to improve the status of the art program. The cost for such outside expertise is often minimal, but the benefits can be substantial.

Q How can the attention, trust, and support of educational decision makers be gained during any period, let alone one of significant educational reform?

A Educational decision makers are as committed to providing quality education for the students in their school districts as any other partner in the educational process. Art specialists, conditioned as they are to existing on the periphery of the system, may develop the perception that they are undervalued by those who control the purse strings (Dunn, 1986).

The key to gaining attention, trust, and financial support is to structure the art program so that it brings honor and distinction to the school (and the school's leaders) as it strives to attain the academic goals that have been established. In a nutshell, if a program can make those who control school budgets look good, they will support that program.

Begin by researching the goals of your school district and the art program. Compare and contrast them. Note any convergence or overlap that points to how the art program is helping the school district meet its

stated goals. Become an information collector or form an information collection team. Each member of the team should be charged with collecting all information concerning the educational benefits of visual arts programs (Dunn, 1992). Use the information collected to educate decision makers concerning the value of art education in reaching district-wide educational goals.

Remember, anything you can do to elevate your school or school district in the eyes of the public is of extreme importance to the leaders of your schools. Periods of educational reform offer opportunities to make substantive change in the basic structure of the system. If art education wishes to achieve legitimacy then the field must document its value, its worth to the development of all children.

Q What benefits can accrue to the visual arts if a thorough assessment of the program is conducted?

A Assessments point out successes and failures. It is important to know what is being done well and what can be done better. Art education has a history of making substantial but undervalued contributions to the cognitive, emotional, and creative development of children. One of the major reasons these contributions have been undervalued is the inability, lack of attention, or both to document the types of learning children acquire in art in ways that make sense to other partners in the educational system.

By assessing the art program, and the curriculum that drives it, the "connective tissue" that links the visual arts to the rest of the general curriculum, and therefore, to development of the total child, can be examined. Documenting and improving the educational legitimacy of the visual arts will secure it a place closer to the core of the general educational structure. Only when this happens will art teachers' feelings of isolation discussed earlier disappear.

Some Final Thoughts

The process of writing this book has dominated my thinking in art education for almost 2 years. During this time I have read thousands of pages, questioned my own thoughts and practices, spoken with many of my peers, and most importantly, listened to hundreds of art teachers voice their apprehensions, frustrations, and desires concerning their art programs. Throughout all of this basic information gathering, *the problems caused by the lack of a clearly articulated, developmentally appropriate, sequential, cumulative, and socially relevant curriculum in art were painfully apparent.* Because art teachers are the most crucial members of our field, I have tried to write a book for them. A book that blends theory with practice—that examines what we do, why we do it, and how we might use curriculum development in art to make what we do better.

This synthesis of ideas, feelings, notions, and beliefs is merely one person's interpretation of existing conditions and vision for looking ahead with an eye toward affecting change in our field. I am well aware that change is a difficult commodity and that it does no good to make change for change's sake. Art educators must be sensitive and thoughtful in seeking to use curriculum as a vehicle for strengthening art's foothold in American education.

I would be remiss if I did not close with the caution that *there is no one right way* to accomplish the aspirations contained in this volume. Just as there is no "best" curriculum, there is no single strategy or approach that will yield the desired results. But *I am convinced that creating the kind of district level art curriculum discussed here is the key to carving out art's rightful place within the educational system.*

Leading, working smarter, learning to "play the game," and successfully marketing the art program all draw from and depend upon having a strong, responsive, and relevant curriculum. Even evaluating student progress in the visual arts and assessing art programs themselves depend upon the curriculum for structure and guidance.

The purpose of this book has been to examine current conditions for art education (what is) and ask the reader to think about what ought to be. The history of curriculum development in art, art's place within the educational system, and ways to create curricula that help improve both have been of paramount importance. By blending history, theory, and practice, I have attempted to provide a multifaceted model for art teachers to use as a starting point in their efforts to improve art education as we prepare to enter the 21st century. I hope that readers see this as an attempt to *empower art specialists* to work together to create the future of our field rather than allow that future to be created for us.

APPENDIX A

Appendix A

CONCEPTS, CONSTRUCTS, DISCIPLINES, PRINCIPLES, AND TERMS: A CURRICULAR FLOWCHART FOR ART

Grade:	K	1	2	3	4	5	6	7	8	9	10	11	12
Disciplines of Art													
Art Production													
Aesthetics													
Art Criticism													
Art History													
Metacognitive Skills													
Comprehend													
Visualize													
Summarize													
Predict													
Self-Question													
Cognitive Skills													
Compare													
Recall													
Analyze													
Evaluate													
Interpret													
Infer													
Synthesize													
Principles of Creativity													
Curiosity													
Experimentation													
Imagination													
Originality													
Flexibility													
Fluency													
Invention													
Elaboration													
Intuition													
Principles of Design													
Repetition													
Rhythm													
Variation													
Balance													

Grade:	K	1	2	3	4	5	6	7	8	9	10	11	12
Contrast													
Dominance/Emphasis													
Unity													
Elements of Design													
Line													
Shape													
Space													
Form													
Texture													
Depth													
Value													
Color Theory													
Color/hue													
Primary													
Warm/Cool													
Secondary													
Tertiary/Intermediary													
Complimentary													
Neutral													
Intensity													
Monochromatic													
Tint/Shade													
Local Color													
Triadic color													
Simultaneous Contrast													
Visual Concepts & Related Constructs													
Art													
Artist													
Description													
Observation													
Original													
Ranking/Sorting													
Relationships													
Technique													
Aesthetician													

Grade:	K	1	2	3	4	5	6	7	8	9	10	11	12
Architect													
Architecture													
Art Critic													
Art & Nature													
Art & Technology													
Beauty													
Craftspersonship													
Design/Composition													
Emotion/mood													
Geometric													
Horizon/Ground line													
Organic/Inorganic													
Overlap													
Pattern													
Self-image													
Sequence													
Size													
Art Historian													
Assemblage													
Collage													
Craft													
Decoration													
Style/Period of Art													
Symmetry/Asymmetry													
Visual Weight													
Abstract													
Construction													
Deconstruction													
Distortion													
Fore/background													
Non-objective													
Proportion													
Non-representational													
Representational													
Art Vocations													
Highlight													
Perspective													

Grade:	K	1	2	3	4	5	6	7	8	9	10	11	12
Rendering													
Shadow													
2D/3D													
Aerial Perspective													
Kinetic													
Animation													
Armature													
Figure/Ground													
Motif													
Positive/Negative													
Academic relevance													
Atmospheric perspective													
Chiaroscuro													
Composite													
Detail													
Fragmentation													
Perception													
Scale													
Symbolism													
Architectural Facade													
Linear Perspective													
Transformation													
Typography													
Graphic Design													
Patronage													
Propaganda													
Visual Communication													
Subject Matter/Themes													
Fantasy													
Realism													
Multiculturalism													
Portraiture													
Caricature													
Frontal													
Profile													
Land/city/seascape													
Still Life													
Genre													
Religion													

Table 3
School Arts Program Curriculum Overview
Grade Level:_____

Goals:	Themes:	Concepts:	Aesthetic Perception:	Creative Expression: Media & Techniques (AS)	Cultural Heritage: Periods, Styles, Artists (AH)	Aesthetic Valuing: (AC)	Art Doctrine Philosophy of Art (AES)	Evaluation & Assessment

	Concepts Objectives	Instruction Motivation	Student Activities	Evaluation
Table 4 Unit Plan				
Aesthetic Perception				
Creative Expression (AP)				
Cultural Heritage (AH)				
Aesthetic Valuing (AC)				
Art Doctrine (AES)				

Table 5 Lesson Plan
Teacher: Grade: Time Allowed: **Problem Title & Thematic Description:**
Art Concepts/Content:
Instructional Objectives: (The child will be able to...)
Instruction/Motivation/Resources/Vocabulary:
Production:
Evaluation: Measuring student learning (i.e., self-assessment, individual critiques, class critiques, anecdotal records, journals, sketch books, check sheets, examinations, class participation, and effort).
Materials: (Media)
Lesson Assessment: (How can this lesson be improved?)

APPENDIX B

GLOSSARY OF TERMS

Author's Note: Many of these conceptual terms, their definitions and their sequencing were developed over a period of time through discussions, workshops and seminars with graduate students and public school art teachers. I would particularly like to commend the work of South Carolina art teachers in Berkeley County, Columbia (Richland School Districts #1 and #2, Lexington School Districts #2 and #5), Spartanburg School Districts #1-7, and the Greenville County School District for their insights.

Abstract. Art which places emphasis on distortion of reality by distorting or otherwise changing color, line, or the like in dealing with subject matter.

Academic Relevance. The close logical relationship between the study of art and scholarly learning.

Achromatic. Having no color at all.

Advancing Color. Warm colors or those of bright intensity which appear to come forward in a work of art.

Advertisement/Logo. Public announcement, printed notice. A logo is a visual symbol for a business, club, or group.

Aesthetics. The study of beauty in all its forms; an awakening of the senses. The opposite of anesthetics which dull the senses.

Aesthetic Pluralism. An approach to the study of art which attempts to broaden individual perspective and build appreciation for culturally diverse forms of artistic expression.

After Image. An optical illusion produced by the human eye in the complementary color of an object viewed for a period of time.

Analogous Colors. Colors which are adjacent on the color wheel and having a color in common. Usually analogous colors should lie between two primaries or two secondaries.

Analogy. A form of logical inference that supposes that if two things are alike in some known way, then they may be alike in other ways.

Analysis. Separation of a whole into its component parts. In art, analysis often refers to examining complex visual forms, their elements, and the relationships between and among them.

Animation. The illusion of movement caused by successive presentations of inanimate objects in rapid order.

Application. The act of putting or rubbing something on. Putting to use. Also, continued effort or close attention to a duty.

Approximate Symmetry. A form of balance where elements on either side of an artwork are visually equal without being identical.

Arch. A curved, weight-bearing architectural support.

Architect. An individual who designs buildings.

Architecture. The art of designing and making buildings. The study of space and places.

Armature. A skeletal support used as the underlying framework for a piece of sculpture.

Arrangement. Items placed together with a purpose in mind.

Art. The expression of beauty in all its forms.

Art and Nature. The relationship of art to nature.

Art and Politics. The relationship of art forms to various ideologies of society.

Art and Religion. The relationship between art and religious worship.

Art and Technology. The relationship between art and human made tools, particularly contemporary image-making tools like computers, and other forms of electronic media.

Art as Language. The use of visual imagery (symbols) to communicate ideas much in the same way as written language.

Art Criticism. The processes and skills involved in viewing, analyzing, interpreting, and judging works of art. Art criticism is one of the parent disciplines of art.

Art History. The field of study which identifies and classifies art works in cultural and chronological context. Art history is one of the parent disciplines of art.

Art Production. The processes and skills involved in the creation of works of art. Art Production is one of the parent disciplines of art.

Art Vocations. Careers which employ art knowledge in order to function within the field.

Artisan. A highly skilled craftsperson; an artist, one who practices an art.

Artistic style. Relating to the shared characteristics of an artist's or several artists' works.

Assemblage. A three-dimensional composition made from mundane or discarded materials.

Asymmetrical Balance. A dynamic relationship caused by compositions which utilize informal or unequally weighted visual relationships to achieve balance.

Atmosphere. In art, the mood or specific expressive qualities of a work of art.

Avant Garde. Art which seeks to be experimental, unconventional, and daring.

Background. The part of a work of art that appears to be in the distance.

Balance. The appearance of stability or the equalization of elements in a work of art. Balance is one of the principles of design.

Bas-relief. Raised or indented features which remain close to the surface.

Body Language. Nonverbal communication through body gestures, movements, and the like.

Body Ornament/Adornment. Decorating the body artistically by means of painting, cosmetics, clothing, or jewelry.

Calculation. To figure out using mechanical or numerical means. To measure.

Calligraphy/Calligraphic. The study or practice of creating decorative, handwritten documents. Flowing, rhythmic lines which intrigue the eye as they enrich surfaces.

Caricature. A representation in which distinctive features or peculiarities are selectively exaggerated to produce a comic or grotesque effect.

Cartoon. A visual image which emphasizes humor. A preliminary study for a work of art.

Change. To make different.

Cityscape. A scenic view of an urban environment.

Close. To shut, finish, or connect in some fashion.

Closure. Bringing a process or experience to an end.

Collage. To bring or fit together. An artistic composition made from mundane or discarded materials.

Color. The hue, value, and intensity of an object as seen by the human eye. Color is one of the elements of design.

Comic art. Art intended to provide amusement or provoke laughter.

Commercialism. Attending to the salability of a product, in this case art. A term often used as a criticism in evaluating art.

Comparison. The process of discovering resemblances or differences. To examine qualities in a work of art.

Complementary Colors. Colors which are opposites on the color wheel and contrast with each other. When mixed together they make neutral brown or gray.

Comprehend. To perceive or understand.

Composite. Bringing together parts of several unrelated objects to form a new object.

Concave. Rounded inward like the inside of a spherical bowl.

Construction. Building up, adding on as opposed to subtracting from to form a work of art.

Contemporary Art. Art of the present day or very recent past.

Contour. A line which defines the outer and inner form of an object or person.

Contrast. The achievement of emphasis and interest in a work of art through differences in values, colors, textures, and other elements. Contrast is one of the principles of design.

Convex. Curved or rounded like the exterior of a sphere.

Craftspersonship. Skill or mastery in a medium or technique. The ability to manipulate materials in a masterful way.

Criticism. The description, analysis, interpretation, and evaluation of works of art. The act of art criticism implies the application of rules and principles which govern decisions instead of merely emotional reactions to works of art.

Cultural Pluralism. The existence of multiple sets of cultural values within the world or society.

Curiosity. An interest in the unexplained or unusual. Being inquisitive. Commonly thought to be one of the qualities necessary for creative thinking.

Decoration. Embellishment, enrichment, or elaboration pertaining particularly to surface qualities in a work of art.

Demonstrate. To prove by pointing out; to exhibit; to explain by showing.

Depth. In a work of art, the real or illusionary feeling of near and far.

Description. Discourse intended to provide a mental image of something experienced.

Design. Artistic invention. The organization of art elements and principles into a structure. To compose, plan, sketch, or outline a procedure.

Detail. To specify, elaborate, or embellish. Small or minute aspects of an object.

Differentiation. To be able to categorize or disembed objects from the visual array in an increasingly sophisticated fashion.

Discord. Lack of agreement or harmony; disunity, clashing or unresolved conflict.

Distortion. Changing, rearranging, or exaggerating the shape or appearance of something.

Dominant. Commanding, controlling, or prevailing over all others.

Double Complimentary. Combinations of two hues with their corresponding complements (for example, yellow orange and yellow green with red violet and blue violet).

Earth Color. Colors such as umbre, yellow ocher, mustard, and terra cotta which are found in the earth's strata. Brown is usually a component of an earth color.

Elaboration - Embellishment. Making more detailed or sophisticated. Developing dramatic strengths and meaning.

Emotion. A response based in feeling. The visual expression of a feeling in a work of art.

Empathy. The capacity for sharing another's feelings, ideas, or situation.

Emphasis. Placing an added importance on one aspect of an art work through the use of any of the elements or principles of design.

Environmental Art. Art that forms, represents, or examines the relationship of art to the world around us.

Environmental Design. An attempt to produce environmentally safe, aesthetically pleasing and functionally satisfying living conditions.

Evaluate. To measure, classify, or judge.

Experimentation. The systematic exploration of media, techniques, and processes in order to uncover properties which can be utilized to create or analyze works of art.

Expression. The act of putting thoughts or feelings into words, images, or actions.

Facade. The front or most important face of a building.

Fantasy. The use of imagination or dream images in a work of art.

Fashion. The style in which a thing is made or done.

Fashion design. The art of creating clothing or adornment for the human body.

Figure/Ground Reversal. A type of visual image which creates the illusion whereby the foreground and background become interchangeable.

Flexibility. The ability to entertain a variety of possible ideas or concepts as potential solutions to a visual problem.

Fluency. The ability to generate a large number of possible solutions to a given problem.

Foreground. The part of an art work which appears to be closest to the viewer.

Form. The three-dimensional structure of an object.

Formal Analysis. An analysis of a work of art based primarily on the elements and principles of design.

Fragmentation. Dividing an object or image into segments or parts.

Frontage/Rubbings. The act of "lifting" an impression from a textured surface by placing a piece of paper in contact with the surface and rubbing it lightly with a mark-making tool.

Functional Art. Art which has a purpose or use, beyond its aesthetic value. Simply stated, art that is useful as well as pleasing to the eye.

Generalization. A broad principle, statement, or idea.

Genre. The representation of people and scenes from everyday life.

Geometric. Utilizing rectilinear or curvilinear motifs.

Graphic Design. Visual communication utilizing print and artistic renderings of objects for commercial purposes.

Grid. A network formed by intersecting equally spaced horizontal and vertical lines. Grids may also be constructed from diagonal or circular lines.

Half-drop Patterns. Motifs which are reduced to half their heights.

Harmony/Unity. An arrangement of color, size, shape, and the like that is pleasing to the eye. Fitting together well; oneness. Simply stated, the quality of having all the parts of a work of art look as if they belong together. Harmony/unity is one of the principles of design.

Hieroglyphics. Characters (pictures or symbols representing or standing for sounds, words, ideas) in the picture writing systems of the ancient Egyptians.

Historical Progression. The placement of art and other aspects of society into a cultural and historical time line.

Horizon Line. The line, either real or implied, in a work of art that marks where the sky and the ground appear to meet.

Hue. The property of a color that makes it appear red, yellow, or the like to our eyes. Hue is often used as a synonym for color.

Identification. The act of recognizing, naming, or classifying.

Illusion. A misleading image presented to the viewer.

Illustration. A work of art that usually seeks to join visual and discursive information for the purposes of communication.

Illustrator. A person who creates illustrations.

Imagery. In visual art, the art of making pictorial language.

Imagination. The power of forming mental pictures of things that are not physically present to the senses.

Implied Line. Lines which are suggested by the close spacing of values, edges, or objects.

Industrial Design. The production of technical designs for factory-made products used in industrial enterprises.

Infer. To presume, assume, deduce, or conclude.

Intensity. The brightness or dullness of a hue or color.

Interaction. Mutual or reciprocal action or influence. To work together in concert or in opposition.

Interior Design. The act of structuring inside living environments so that they are both functional and aesthetically pleasing to the senses.

Interpret. To explain or clarify. In art the ability to decode or uncover meaning in works of art.

Intuition. Feelings, inspirations, or instincts which spring from the subconscious and affect our approaches to creating art or the ways in which we respond to art.

Invention. The ability to make up or produce something for the first time.

Kinetic Art. Art which moves.

Landscape. A scenic view of land, usually a country area.

Lens. A piece of polished glass capable of bending or focusing rays of light.

Light. That which makes it possible to see. Illumination, radiance, or brilliance.

Light Theory of Color. A system for studying the spectrum by blending or refracting rays of light. The primary colors in the light theory of color are yellow, cyan, and magenta.

Line. The path of a point moving in space. The outline or contour of an object. Lines can exist in either two or three dimensions. Line is one of the elements of design.

Linear Perspective. A system of image making which utilizes lines and vanishing points to create the illusion of depth on a flat surface.

Local Color. The pure hue as seen when unaffected by any other colors.

Measurement. A figure, extent, or amount obtained by quantifying dimension.

Memorabilia. Items saved by people as reminders of the past.

Metaphor. A figure of speech in which one thing is likened to another and spoken of as if it were the other, for example, "all the world's a stage."

Mobility. Movement, the ability to change position or alter visual relationships.

Modeling. The act of manipulating a material. A term often used in art to describe the act of sculpting. To create the illusion of form and depth through shading. The act of posing for an art work.

Monochromatic. A color scheme which utilizes only the tints, tones, and shades of a single hue.

Montage. A collection or grouping of pasted photographic images used to create a work of art.

Mood. The expression of an emotion.

Motif. A basic element (i.e., shape) which is repeated to form a pattern.

Movement. The direction or path of relating lines, color, and the like that lead the eye over and through a work of art. A school, style, or period of art.

Narrative Qualities of Art. Art works which tell a story.

Natural. Being in accordance with or determined by nature. Existing in or produced by nature. A close resemblance to an actual object.

Negative. The opposite of positive. A reverse impression as in a photographic negative. The air or environment surrounding a sculpture as in negative space.

Neutrals. Black, white, and gray. In pigmentation theory, brown is also sometimes considered a neutral.

Nonfunctional. A term which describes an object whose sole use is intended for decoration or visual appeal.

Non-objective (non-representational). Art that has no recognizable subject matter.

Objective (Representational). Art that recalls an image or idea. Portraying things much as they appear.

Observation. The act, habit, or power of seeing and noting.

Open. Having gaps, spaces, or intervals. The opposite of closed.

Organic. Freeform, curvilinear, or natural shapes as opposed to geometric shapes or forms.

Originality. The quality of being unique, fresh, or new. The ability to think, do, or create in a way that has not been done before.

Overlap. One shape or part covering up some part or all of another. Overlapping objects always appear to be closer than the objects they cover. The use of overlap is a technique often used to create the illusion of depth in a two-dimensional work of art.

Patronage. The support and/or influence of lay people for or over any of the arts.

Pattern. Forms, lines, or symbols that move across a surface in a prearranged sequence. The repetition of motifs or elements of design. A pattern can also be a mold or model designed to be copied.

Perception. Cognitive activity derived from sensory data. Any insight, intuition, or knowledge. In visual art, the ability to disembed or differentiate information from the visual array.

Perpendicular. Coming at a 90 degree angle.

Perspective. The representation of three-dimensional objects in spacial recession on a two-dimensional surface. Simply stated, the way in which the appearance of objects and the distances between them are made to look real.

Photographic. Representing nature and/or human beings with the accuracy of a photograph.

Photography. An art or process of producing a negative or positive image directly or indirectly on a sensitized surface by the action of light or other form of radiant energy.

Pictographs. Pictures which represent an idea or story, as in primitive writing. Simply stated, picture writing.

Picture Plane. The imaginary transparent plane which stands vertically between the artist and subject. Linear perspective measurements include relationships involving the picture plane.

Pigmentation Theory of Color. A system for studying the spectrum which utilizes the properties of natural and human-made materials to make the colors of the spectrum.

Plastic. Capable of being molded or formed.

Point of Departure. The subject or visual problem used as an idea or inspiration for a composition.

Portraiture. The pictorial representation of a particular person or animal.

Positive. Having real and/or present qualities. The opposite of negative.

Predict. To speculate, anticipate, theorize, calculate, estimate, or make an informed guess. In art, most prediction concerns solving visual problems or identifying unknown works from other cultures or eras.

Primary Colors. In pigment, the colors red, yellow, and blue. Colors that cannot be mixed from other colors.

Product Design. The production of objects that are both functional and pleasing to the senses.

Profile. An object seen from the side. Something seen in sharp relief.

Propaganda. The spread of exaggerated or untrue ideas or information which has been deliberately designed to further one's cause or damage an opposing cause.

Proportion. The relationship between objects or parts of objects. The relative size of a part in relation to the whole.

Psychological Effects of Color. The intellectual, emotional, and physiological effects or impact of color.

Radial Pattern. A pattern which spirals out from a central point.

Radiating. Emanating or protecting outward from a central point.

Ranking - Putting some special order to a list or group of objects or persons. Having a certain place or position in relation to other persons, things, or objects.

Rationale. A justification often based on philosophy and/or logic.

Receding Colors. Cool colors or colors of low intensity which appear to recede in a work of art.

Refinement. Precise improvement through simplification or elaboration.

Reflection. The return of light rays from a surface. Looking inward or backward, a pensive mood. The act of pondering or meditating.

Regionalism. A term used to describe the effects and contributions of art forms that are identified with or emanate from particular parts of a country.

Relationships. A connection between or among two or more objects or concepts. A condition of belonging to the same family or category.

Rendering. A depiction which seeks to reproduce an object as closely as possible.

Repetition. Recurring over and over again. Repetition is one of the principles of design.

Research. The process whereby new knowledge is uncovered or previous knowledge is combined (synthesized) to develop new understandings or perceptions. In art, research can take many forms and be both theoretical or applied.

Rhythm. The flow or movement within a work of art. The pace at which the eye travels over an art work. Rhythm is one of the principles of design.

Scale. The ratio of the size of various parts in a drawing, sketch, or art work to their size in the original. If a picture is drawn to scale, all of its parts are equally smaller or larger than the original.

Seascape. A scenic view which features large expanses of water.

Secondary Colors. In pigment, the colors orange, green, and violet. Colors that are derived by mixing any two of the primary colors together.

Self-image. One's conception of one's self or of one's role. A concept often connected with an evaluation of self-worth. A visual representation of one's self as in a self-portrait.

Self-question. To consider with an open mind one's position or reaction toward a visual problem or work of art.

Sensory literacy. The development of multiple forms of literacy which utilize information garnered by each of the senses.

Sensuality. A quality or state of being which stimulates the senses.

Sequencing. A sophisticated form of ranking. Determining the order of things. Continuity of progression. A continuous or connected series.

Shadow. The area of darkness cast when light falls on any object.

Shade. Any hue plus black.

Shape. A two-dimensional (flat) area formed when a line meets itself. Shape is one of the elements of design.

Simile. A figure of speech comparing two unlike things. Unlike a metaphor, the comparison is exact, for example, tears flowed like wine.

Simultaneous Contrast. The effect one color has on another when they are placed in close proximity to each other.

Size. The relative or proportional dimensions of an object.

Skeletal Shape. The underlying structure of an object.

Social relevance. Art works that seek to comment upon and affect attitudes of a given society.

Sorting. Arranging by kinds or classes in order.

Space. Two- or three-dimensional areas in a work of art. Space can be positive or negative. The area completely contained within a shape. Space is one of the elements of design.

Split Compliments. The name given to a color scheme which combines a hue with the hues on either side of its compliment on the tertiary color wheel.

Still Life. An arrangement of objects, often common in nature, as subject matter for the production of a work of art.

Stroboscopic. Creating the illusion of rotating or vibrating objects through the use of pulsed illumination.

Style. An artistic technique; a means of expression as a way of showing the unique qualities of an individual culture or time period.

Subject Matter. The symbols or materials used in a work of art to convey what the artist wants to communicate.

Subordinant. Placed in or occupying a lower class or rank.

Summarize. To review, reiterate, compress, condense, or outline one's position or reaction to one's own art work or the art works of others.

Symbolism. An image or idea that stands for, represents, or takes the place of an actual image or idea.

Symmetry. A design in which both sides are identical.

Synthesis. Combining separate elements to form a coherent whole; a joining together of previously separated elements.**Technique.** A way of using methods and materials to achieve a desired result.

Tension. A balance maintained in an artwork between opposing forces or elements.

Tertiary or Intermediate Colors. Colors produced by mixing a primary with a secondary color.

Texture. The surface characteristics of an object such as roughness or smoothness or whether an object is glossy or dull. Texture can be actual or implied. Texture is one of the elements of design.

Three Dimensional. Possessing the qualities of height, width, and depth.

Time Lapse. A series of images which seek to document the passage of time.

Tint. Any hue plus white.

Tone. Any hue plus its complement or gray.

Transfer. To convey a picture or design from one surface to another by any of several processes. For example, printmaking, carbon paper, xerox, press type, and so forth.

Transformation. A change in structure, appearance, or character. To change from one form into another.

Triadic. Three hues which are equally distant on the color wheel.

Two Dimensional. Possessing the qualities of height and width.

Unity. The oneness or wholeness of a work of art. Unity is one of the principles of design.

Value. The lightness or darkness of a color or neutral. Value is one of the elements of design.

Vanishing Point. The point at which lines that are parallel to each other, but at an angle to the picture plane, appear to meet.

Variation. Diversifying elements within an art work to add visual interest. Variation is one of the principles of design.

Vision. Imaginative insight; the act of seeing.

Visual Communication. The use of visual imagery to transmit ideas, feelings, or impressions in a nondiscursive fashion.

Visual History. Information or knowledge about the past that comes to us from visual artifacts.

Visual Illusion. A perception that appears real to the sight but in truth is not real.

Visualize. To picture in the mind's eye. To conceive or imagine not to escape from reality but to envision what could be.

Volume. The amount of space occupied in three dimensions. Cubic magnitude.

Warm and Cool Colors. Warm are orange, red, yellow; cool are blue, green, and violet.

Weight. The relative importance or impact, strength, or heft of any part of a work of art.

Width. Wideness, breadth.

REFERENCES

Alexander, K., & Day, M. (Eds.). (1991). *DBAE: A curriculum sampler.* Los Angeles: Getty Center for Education in the Arts.

Barkan, M. (1966). Curriculum problems in art education. In E.L. Mattil (Ed.), *A seminar in art education for research and curriculum development* (USDE Cooperative Research Project No. V-002; pp. 240-255). University Park: The Pennsylvania State University.

Bloom, B.S., et al. (1956). *Taxonomy of educational objectives, Handbook I: Cognitive domain.* New York: Longman, Inc.

Broudy, H.S. (1972). *Enlightened cherishing: An essay on aesthetic education.* Urbana: University of Illinois Press.

Chapman, L. H. (1982). *Instant art instant culture: The unspoken policy for American schools.* New York: Teachers College Press.

College Entrance Examination Board. (1985). *Academic preparation and the arts.* New York: College Board Publications.

Clark, G., Day, M., & Greer, D. (1987). Discipline-based art education: Becoming students of art. *Journal of Aesthetic Education, 21*(2), 129-197.

Cromer, J. L. (1990). *The history, theory, and practice of art criticism in art education.* Reston, VA: National Art Education Association.

Dewey, J. (1934). *Art as experience.* New York: Minton, Balch.

Diblasio, M.K. (1985). Continuing the translation: Further delineation of the DBAE format. *Studies in Art Education, 26*(4), 197-205.

Dorethy, R., & Reeves, D. (1978). Mental functioning, perceptual differentiation, personality and achievement among art and non-art majors. *Studies in Art Education, 20*(1), 49-55.

Dunn, P.C. (1981). Evaluation and the arts. *Design for Arts in Education, 82*(5), 27-30.

Dunn, P.C. (1986a). Beyond the elements and principles of design: Discipline-based art education and the future of our field. Paper presented at the annual convention of the National Art Education Association.

Dunn, P.C. (1986b). Help! My principal just burst "my you gotta have art" balloon. *Design for Arts in Education, 87*(2), 35-38.

Dunn, P.C. (1987). Art, cognition and curriculum: A DBAE approach. Paper presented at Theory into Practice: Discipline-Based Art Education, a conference sponsored by the Kansas City Art Institute, Art Education Connection and the National Endowment in the Arts.

Dunn, P.C. (1992). Twenty ways to improve your program's position in the educational system. In Andra S. Johnson (Ed.), *Elementary art anthology* (pp. 77-87). Reston, VA: National Art Education Association.

Dunn, P.C., Cromer, J.L., Debauche, L., Hatfield, T.A., Saunders, S., & Gilbert, E. (1981). *Staff development in art.* Columbia: South Carolina Department of Education.

Edwards, B. (1979). *Drawing on the right side of the brain.* Los Angeles: Tarcher.

Eisner, E. W. (1972). *Educating artistic vision.* New York: MacMillian.

Eisner, E. W. (1982). *Cognition and curriculum.* New York: Longman.

Eisner, E. W. (1985). *The educational imagination: On the design and evaluation of school programs.* New York: Macmillian.

Gardner, H. (1983). *Frames of mind: The theory of multiple intelligences.* New York: Basic Books.

Greer, W.D. (1984). Discipline-Based art education: Approaching art as a subject of study. *Studies in Art Education*, 25(4), 212-218.

Hirsch, E.D. Jr. (1987). *Cultural literacy, What every American needs to know.* Boston: Houghton Mifflin Company.

Lanier, V. (1981). Six items on the agenda for the eighties. In G.W. Hardiman & T. Zernich (Eds.), *Foundations for curriculum development and evaluation in art education.* Champaign, IL: Stipes Publishing Co.

Lowenfeld, V. (1947). *Creative and mental growth.* New York: Macmillian.

McFee, J. (1961). *Preparation for art.* San Francisco: Wadsworth.

McLuhan, M. (1967). *The medium is the message.* New York: Prentice Hall.

National Endowment for the Arts. (1988). *Toward Civilization: Overview from a report on arts education.* Washington DC:

Piaget, J. (1970). Piaget's theory. In P.H. Mussen (Ed.), *Carmichael's manual of child psychology* (Vol. 1). New York: Wiley.

Read, H. (1956). *Education through art* (3rd. ed.) New York: Pantheon Books.

Reimer, B. (1992). Towards percipience: A humanities curriculum for arts education. In *The Arts, education and aesthetic knowing* (NSSE Yearbook). Chicago: University of Chicago Press.

Stake, R. (1975). *Evaluation and the arts in education.* Columbus: Charles E. Merrill Co.

Unruh, G. G., & Unruh, A. (1984). *Curriculum development: Problems, processes, and progress.* Berkeley: McCutchan.

U.S. Department of Education. (1983). *A Nation at risk: The imperative for educational reform.* Washington, DC: U.S. Government Printing Office.